# "HOW DO I PHOTOGRAPH A SUNSET?"

An Hachette UK Company
www.hachette.co.uk

First published in the UK in 2021 by
Ilex, an imprint of
Octopus Publishing Group Ltd
Carmelite House
50 Victoria Embankment
London EC4Y 0DZ
www.octopusbooks.co.uk
www.octopusbooksusa.com

Distributed in the US by
Hachette Book Group
1290 Avenue of the Americas
4th and 5th Floors
New York
NY 10104

Distributed in Canada by
Canadian Manda Group
664 Annette St.
Toronto, Ontario
Canada M6S 2C8

Publisher: Alison Starling
Commissioner: Richard Collins
Managing Editor: Rachel Silverlight
Editorial Assistant:
Ellen Sandford O'Neill
Art Director: Ben Gardiner
Designer: Chris Robinson
Assistant Production Manager:
Allison Gonsalves

ISBN 978-1-78157-821-6

A CIP catalogue record for this book
is available from the British Library.

Printed and bound in China

10 9 8 7 6 5 4 3 2 1

# "HOW DO I PHOTOGRAPH A SUNSET?"

## MORE THAN 150 ESSENTIAL PHOTOGRAPHY QUESTIONS ANSWERED
### Chris Gatcum

# Contents

# 2 IN THE BEGINNING

# 5 IN THE DIGITAL DARKROOM

## HARDWARE

## SOFTWARE

## TECHNIQUES

# Introduction

I still remember my first 'proper' camera. It was a pre-owned Olympus OM-G 35mm SLR with a 50mm f/1.8 lens. According to the man in the camera shop it was the American version of the company's OM20, which had somehow made it to the UK, making it seem even more exotic. As I held the silver body in my hands I felt excited and apprehensive in equal measure. Excited because I had been lusting after this camera for months, working a part-time job after school and saving hard to afford it. Apprehensive because, well, I had no idea how to actually use it.

You see, my previous photographic endeavours had been with a fully automated Kodak Pocket Instamatic camera that my mum had picked up at a second-hand shop a few years before. Taking 110 film cartridges, the Kodak made photography about as easy as it gets: point and shoot were the only things I had to do. But with the OM-G, I now had two shooting modes (Aperture Priority or Auto, as Olympus called it, and Manual), a dial on top with + and − numbers on it (whatever those meant), and a ring of numbers around both the lens and the lens mount. What the heck did it all mean?

That's how it starts for all of us. With bewilderment. Sure, my OM-G's relative lack of sophistication is laughable compared to the features crammed into today's digital cameras, but without a fully automatic mode to hold my hand I was still thrown in at the deep end – and if I wanted to take pictures, I knew I'd have to learn to swim pretty quickly. I needed to find out why I might need to use Aperture Priority instead of Manual (and what those modes were to start with), what the ± dial was for and what the numbers on the lens meant. I had to get answers to those questions, and more, and it seemed that with each answer came more questions.

I know I'm not alone – I can't be, because no one is born with an innate knowledge of photography. At that moment when we pick up our first 'proper' camera (or decide to move away from shooting in full Auto) we are all in the same metaphoric boat. On day one we all have the same questions. It is only by asking what, why, when and how that we can develop and improve, and hopefully learn to take a half-decent photograph (even if we're the only people who see them that way). Of course, that's easier said that done, because to ask the right questions, you first need to know what they are – which is where this book comes in. From deciding which type of camera is right for you to getting to grips with the fundamentals of photography, or troubleshooting a specific shooting scenario, the following pages answer the questions that are asked most often, as well as some that don't get asked nearly as often as they should.

Be warned, though: almost 30 years down the photographic road, I still find the questions keep coming. They may not be as frequent, and past experience often means that the answer is usually less elusive, but if there's one thing I've learned, it's that when it comes to photography there is always something else to discover. There's always one more question. And there's always one more answer.

◀ My first SLR (which I still own after almost three decades) is incredibly simple compared to today's digital cameras, but each of those numbers and settings was a mystery when I started out. Unpicking their secrets taught me about exposure and focus – the same fundamental principles that I would later translate into the digital world, and then back to even more primitive film cameras.

# IN THE BAG

From the camera you choose to the lenses you attach to it, packing the right kit plays an essential part in getting the shots you want.

# Cameras

Picking a camera is potentially the most expensive decision you need to make, so you need to choose carefully.

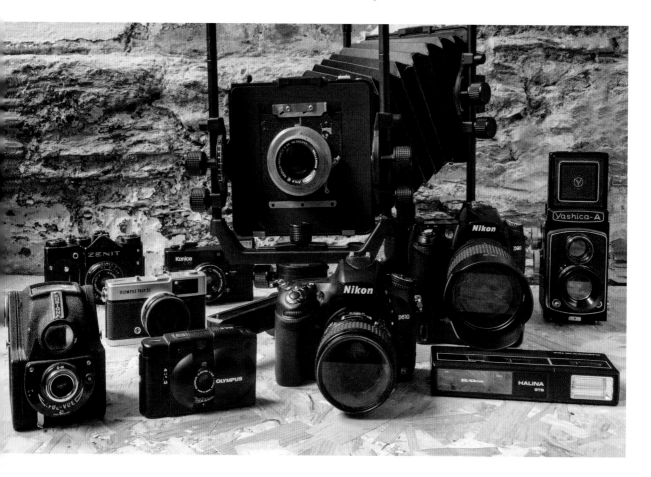

## What's the best camera I can buy?

Some people would say that the best camera is the one you've got with you, because it at least means you can take a photograph, while others would argue that the latest, fully featured, high-resolution digital model is the best option. The truth is, there is no definitive 'best' camera, only the one that works best for you. Aatcompact action camera might be the perfect choice for shooting high-octane, adrenaline-fuelled escapades, but it's not going to be the best camera for photographing wildlife at a distance.

▲ Over the years I've ended up with a whole load of different cameras, of which this is just a selection. It's impossible to say which one is best – they all have different strengths (and weaknesses), which is what makes them all so great!

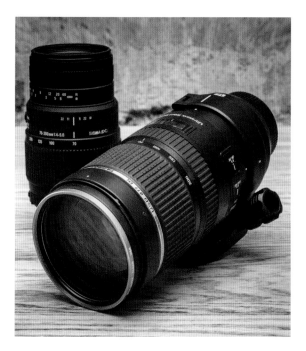

## ◌ Should I spend my money upgrading my camera or my lenses?

Today, the technological advances inside digital cameras are often evolutionary, rather than revolutionary, so you can quite easily skip a generation or two without falling behind in the technology stakes. So, concentrate on your lenses instead, whether that means buying a new lens to expand the focal length range in your armoury or upgrading the lens you use most often to a better-specified version – one with a wider maximum aperture or with image stabilization, for example.

◀ As soon as I could, I upgraded my budget Sigma 70–300mm f/4.5–5.6 zoom to a Tamron 70–200mm f/2.8 stabilized lens. This made a much bigger difference to the quality of my telephoto shots than a new camera would have done.

## ◌ Are full-frame cameras better than cropped-format cameras?

Full-frame cameras certainly have their advantages. They tend to have a higher resolution and/or larger pixels than cropped-format cameras, for example, which can make them less prone to noise (useful if you like shooting in low-light conditions), give them a greater dynamic range (useful for retaining detail in high-contrast scenes), and also lead to more detail in your images (although the lens you use will also play a significant part in this).

However, that doesn't necessarily make them 'better'. If you shoot wildlife, or sports, or something else that requires long focal lengths, a camera with an APS-C or Micro Four Thirds sensor can perhaps be more useful, as the cropped sensor will effectively increase the focal length of a lens by a factor of 1.5–2x. For instance, a 200mm lens on a cropped-sensor camera will act more like a 300mm or 400mm telephoto, giving you extra 'reach' and helping you fill the frame with your subject without having to spend huge amounts on a longer lens. Some would argue that in this scenario a cropped-format sensor is the better option.

▲ ▼ Whether you choose a full-frame or cropped-sensor camera will largely come down to your budget and what you shoot – although it's often seen as the ultimate option, not everyone needs to shoot full-frame.

## Why do some cameras have an anti-aliasing filter, but others don't?

Anti-aliasing (AA) or 'low-pass' filters used to be a standard feature in every digital camera, used directly in front of the sensor to – rather counterintuitively – subtly blur the image. This was done to combat the effects of moiré, which is caused when fine textures (high frequencies) in a scene clash with the grid of the camera's sensor, creating an interference pattern. Blurring the image very slightly meant that this unwanted artefact could be removed completely, which is great, but there is one fairly obvious side effect – the image is not as sharp as it could be. Although sharpening a digital photograph during post-processing can improve things (see page 169), some manufacturers have now decided not to have a low-pass filter or to instead have an electronic AA filter that can be activated when needed. Their reasoning is that moiré doesn't occur that often and most people would prefer optimum image sharpness, which in a lot of cases makes perfect sense.

There are certain situations where you might want to think twice, though: moiré is seen most often when photographing fine-weave fabrics, for example, so portrait photographers are an obvious group that might benefit from having a filter in their camera.

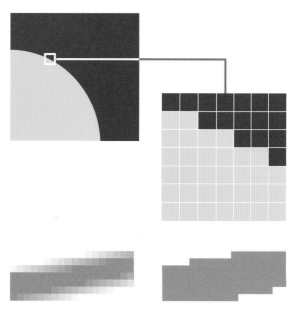

With AA filter          Without AA filter

▲ An anti-aliasing filter softens images slightly to prevent moiré, but some cameras now do without a physical filter and instead have a 'digital AA filter' that can be turned on and off.

## Why do some cameras take two memory cards?

Cameras that take two memory cards can typically be set up in a number of ways, so you can choose how the cards are used. You might use two cards to maximize your storage capacity, for example, with the second card used when the first is full. In that way, two 16GB cards would give you a total of 32GB of storage. Alternatively, you might choose to record every shot you take to both cards simultaneously, so that if one card fails, you still have the images stored on the other one.

Other configurations might allow you to save Raw files to one card and JPEGs to another, so you can quickly and easily upload the JPEGs to a website (for a client to see, perhaps), with the Raw files kept separately, ready for processing. In each case, two memory cards give you greater versatility than one.

▲ I usually set up the dual SD cards in my current DSLR so that when the first is full, images start recording to the second, effectively doubling my storage space.

## ✹ I got caught with my camera in a downpour and now it won't work. Is it ruined?

Unless you're using a weatherproofed camera with rubber seals around the various doors and ports (or a dedicated waterproof casing), there's every chance that water will make its way inside your camera if it's exposed to heavy rain. Lens mounts are particularly prone to damp ingress, and even mist and fog can make mischief if your kit gets damp enough.

The first thing to do is to try and dry it out, but do not use a hairdryer or stand it on a radiator – that's going to do more harm than good. Instead, remove the battery and memory card, and make sure any 'doors' on the camera body are shut and any rubber 'plugs' are fitted.

If it's a DSLR or mirrorless camera, take off the lens and fit a body cap, making sure it's secure (use tape to hold it in place if necessary). Then, fill a large bowl with dry rice and bury your camera in it. Leave it for at least three days – ideally a week – during which time the rice will suck any moisture from the camera and absorb it. When time's up, retrieve your camera, give it a dust down, refit the battery and power it up. If the photography gods are smiling on you everything will be well again. If not, it's time to give your local camera repairer a call.

◀ A few drops of water are unlikely to do your camera much harm, especially if it's weatherproofed, but torrential rain is best avoided.

## ✹ How can I shoot underwater?

Depending on your budget and how serious you are about underwater photography, there are several ways that you can shoot beneath the sea or in a pool. The simplest and cheapest option to dip your toe in is with a single-use underwater film camera, although you will be limited to a certain number of shots (usually 24 or 27).

If you prefer to shoot digitally, there are plenty of action cameras and compact cameras that can be used underwater, or you could think about some sort of waterproof case for your DSLR or mirrorless camera, which will give you the best possible image quality.

Options range from what are essentially thick plastic bags that you put your camera in through to dedicated rigid housings that can be taken hundreds of feet beneath the surface.

▼ This Olympus Tough compact is waterproof up to 15m (50ft) and comes with a host of settings dedicated to getting great underwater shots, including a trio of depth-dependent white balance options.

## ◌ Is an electronic viewfinder better than an optical one?

At a fundamental level, this is the difference between mirrorless cameras, which use an electronic viewfinder (EVF), and DSLRs, which use a mirror and pentaprism (or pentamirror) to present a 'live' image through an optical viewfinder (OVF). In the early days of EVFs, they were small, dark, low-resolution and often had a slight delay or lag, whereas an optical viewfinder was like looking through a big, clean window, so there really was no contest. Today, however, the best EVFs are high-resolution and lag-free, so the difference has narrowed. An EVF can also show you things that an OVF cannot: it can physically lighten and darken to simulate your exposure, show you a histogram, provide a live depth

of field preview, give you a good idea of your colour and contrast settings, and it won't 'black out' when you shoot.

An EVF can also show you 100 percent of what the sensor will record, while many DSLRs will show you 90 percent or less of the scene you are about to record (100 percent coverage is usually reserved for top-flight DSLRs). On that basis, an electronic viewfinder is better than an optical viewfinder in just about every way, although I still personally prefer to peer through an optical 'window' rather than look at a tiny screen.

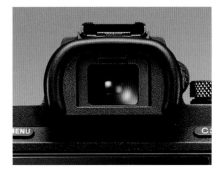

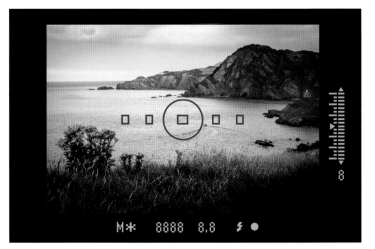

▲ ▶ An electronic viewfinder can show a lot more information than an optical viewfinder, which can help you get things right before you shoot.

## ◌ What does my DSLR's mirror lock do?

When you take a shot with a DSLR, two things need to happen: the mirror that lets you see through the viewfinder needs to flip up out of the way, and the shutter needs to open to make the exposure. Usually, this happens as a single action when you press the shutter-release button, but mirror lock splits the

process into two distinct phases: the mirror flips up with your first press of the button and a second press fires the shutter. It might sound like an unnecessary complication, but when the mirror flips up there's a risk that 'mirror slap' can cause slight vibrations that can lead to camera shake

and slightly blurred shots. Most of the time this isn't anything to worry about, but in some ultra-critical applications it can become noticeable: in macro photography, for example, or when using long telephoto lenses that will magnify the tiniest vibration.

**FULL IMAGE**

**IMAGE AT PIXEL LEVEL**

## ◐ Is a camera with a higher number of megapixels better than one with fewer pixels?

The resolution of a camera is definitely a selling point, but while having more pixels can potentially mean more detail, it also places greater demands on your lenses and technique, so high-quality optics and precise focusing are essential. A high resolution also means that the photosites – the small, light-sensitive receptors on the sensor that record the light that creates a pixel – have to be smaller, so while a 46MP full-frame sensor might deliver more detailed images than a 24MP sensor of the same physical size, the 24MP sensor will have larger photosites that are better at 'catching' light.

This can result in less noise at high ISO settings (if you look closely enough) and a higher dynamic range, although at lower ISO settings you will often find there is no discernible difference, other than slightly more detail from the higher-resolution sensor (again, if you look closely enough). So while a higher pixel count is better in some ways, it isn't the only measure of a camera's capabilities.

◄ Pixels are the building blocks of a photograph. The general rule is that the higher a camera's resolution, the more of these small square blocks it can generate, and the more detail your photographs will have. However, this is often countered by other elements, such as the quality of the lens you're using.

◄ Mirror Up can be beneficial when you're shooting close-ups with a macro lens or using a long telephoto lens, as both of these will magnify the slightest shake. It can work when you're using the viewfinder or Live View (as here), but your camera needs to be mounted on a tripod for it to be effective.

## ⚙ What's a bridge camera?

Back when DSLRs were prohibitively expensive, and compact digital cameras lacked much in the way of control, every manufacturer had at least one aspirational bridge camera in its line-up. These cameras came with a fixed zoom lens and the type of small sensor that was found in compact cameras, but were styled to look like mini DSLRs, with a similar level of manual control. In this way they 'bridged' the gap between the DSLRs that most enthusiast photographers wanted, but couldn't afford, and the compact cameras they could afford, but didn't really want. Unsurprisingly, as soon as entry-level DSLRs became more affordable, the bridge camera market collapsed, and those that are left now rely on huge zoom ranges to try and give them purpose.

◀ Modern bridge cameras, such as Nikon's Coolpix P950, typically combine DSLR-style handling with a small-format sensor and a phenomenal zoom range – in this case equivalent to 24–2000mm on a full-frame camera!

## ⚙ What's the difference between Micro Four Thirds and APS-C cameras?

The simple answer is sensor size. Micro Four Thirds (MFT) cameras use a sensor with an active imaging area of 17.3 x 13mm, while APS-C sensors are somewhere between 24 x 16mm and 20.7 x 13.8mm (different manufacturers use slightly different sizes but still call them all APS-C as a convenient approximation). However, that's only part of the story. MFT is an 'open standard', which means anyone can sign up to make MFT cameras and lenses, as long as they stick to the standard's specifications.

As a result, MFT cameras and lenses are fully interchangeable, regardless of make, so Olympus lenses can be used on Panasonic cameras, for example, enabling you to pick and choose the lenses and cameras that meet your needs, without worrying about compatibility issues.

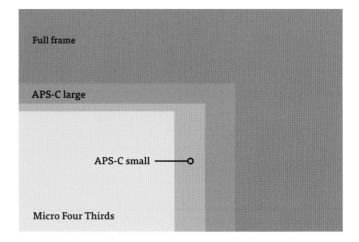

Full frame

APS-C large

APS-C small ———○

Micro Four Thirds

▲ The difference between different digital camera formats primarily comes down to the size of their sensor. As shown here, an APS-C camera has a larger sensor than a Micro Four Thirds camera, which potentially means it will suffer less from noise at high ISO settings and have a higher dynamic range than a camera with a smaller sensor (although this is not always the case).

## ◎ I'm heading off on a skiing trip – what's a good camera to take with me?

Although you could take a DSLR or mirrorless camera (and that would definitely be a good idea for those stunning mountainscapes), this is one of those areas where an action camera will excel. Epitomized by the ubiquitous GoPro, these ultra-compact, super-tough cameras can be mounted to pretty much anything, including your skis, snowboard or helmet, and are capable of shooting high-resolution video or stills that will put your viewer at the heart of the action.

▲ ▶ Waterproof and ruggedized, an action camera is the perfect option for shooting in the snow – use a selfie stick to get yourself in frame, or mount the camera on your helmet to put the viewer on your skis or board with you.

## ◐ I've started noticing dark blurry marks on my pictures – what could they be?

If you're seeing dark spots in a near-identical position from shot to shot, then you're almost certainly looking at dust on your sensor. This is common if you shoot with an interchangeable lens camera (DSLR or mirrorless) and change lenses, as removing the lens opens up the interior of the camera to airborne debris. This can be drawn to the charged sensor where it can potentially stick, resulting in tiny dark blurs that are particularly apparent in blue skies, smooth areas of light skin and other flat expanses of mid-to-light-toned areas in your image.

To help prevent dust landing on your sensor, shelter your camera from any breeze when you change lenses and aim your camera downwards so gravity's on your side as well. A lot of cameras have an anti-dust feature that will vibrate the sensor in an attempt to shake any dust from it, which will help, but even with these systems dust can (and will) build up over time, at which point you will need to clean the sensor.

**DETAIL OF DUST SPOTS**

▲ If you start to see dark spots like this in an image, it might be time to clean your camera's sensor.

## ◐ There's a circle with a line through it engraved on the top of my camera – what does it mean?

The 'focal plane indicator' appears on most camera bodies and shows you where the film or sensor sits inside the camera. For most of us it serves no practical purpose, but there are certain situations when it can prove useful: in critical macro work you can measure from the focal plane indicator to the subject to make sure it's within the minimum focus distance of your lens, for example, while video shooters can use it to measure distances for pulling focus from one point to another.

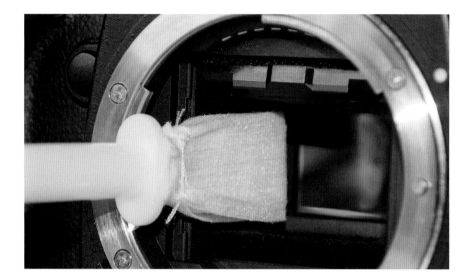

◀ Cleaning your sensor with a swab is the only way to get rid of more stubborn marks.

## How can I clean my camera's sensor?

The simplest option is to get someone else to do it. Any company that offers camera repairs will offer a sensor-cleaning service for a modest fee, as do some photo stores, and the benefit is that you're (hopefully) handing your camera over to someone who knows what they're doing. The alternative is to do it yourself.

The least invasive option is to open the camera's shutter, either in Bulb mode or via a dedicated sensor-cleaning setting, and blow the front of the sensor using a bulb-type blower (see page 39) with the camera pointing downwards. If you're lucky, a puff or two of air will be all that's needed to blow the dust from your sensor, but if you're not so fortunate, you'll need to 'wet clean' the sensor. This involves an element of risk, as you will be wiping the anti-aliasing or infrared filter sitting directly over the sensor, and you're perhaps one involuntary hand spasm away from a cracked filter and an expensive repair. Bear that in mind, and if in doubt, take it to the camera shop for cleaning.

However, if you've got a fairly steady hand, it's a relatively straightforward process involving a cleaning swab that matches the size of your sensor and some cleaning fluid:

- With the sensor exposed and a drop or two of cleaning fluid on your swab, wipe the swab across the surface of the sensor (well, the filter in front of it) from one side to the other.
- Flip the swab over and use the other side to wipe across the sensor in the opposite direction.
- All being well, two wipes is all it will take to give you a spotless sensor. If not, get another swab and repeat the process.

Although this doesn't sound too difficult (and really, it isn't), there are a few essential things to bear in mind:

- Always start with a fully charged battery. If the battery runs out mid-clean, your shutter will close, and you don't want that to happen while you've got a swab in the way.
- Never use the same swab twice, or the same side of a swab more than once. Any dirt it has picked up will at best be put back and at worst scratch the filter you're cleaning.

**35MM ON FULL FRAME – VIGNETTING VISIBLE**

◀ Using a cropped-format 35mm prime lens on a full-frame camera reveals some obvious vignetting (dark corners), as the lens doesn't cover the full area of the sensor.

▼ However, cropping the full-frame shot still results in a larger image area than using a smaller-format sensor.

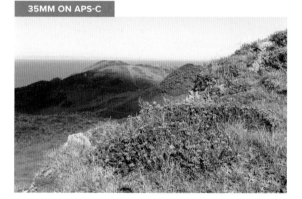

**35MM ON APS-C**

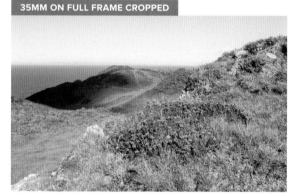

**35MM ON FULL FRAME CROPPED**

## Can I use cropped-format lenses on a full-frame DSLR?

Yes and no. Some full-frame DSLRs let you use lenses designed for smaller-format sensors, so you can use Nikon's DX (APS-C) lenses on its FX (full-frame) cameras, for example, while Sony's E-mount lenses will fit both its cropped-format and full-frame cameras. However, you cannot use Canon EF-S lenses on a full-frame EOS camera, as the back of the lens will hit the mirror in the camera.

For those cameras that offer compatibility, there is typically a dedicated mode that tells the camera to 'pretend' it's a smaller-format camera. This means it uses a smaller part of the sensor, which avoids any

vignetting – darkening at the corners of the frame – that might otherwise occur, and also means that you benefit from the crop factor of the smaller format (see page 18). The downside is that the pixel count of your final images will be reduced because you're not using the full sensor area, but with today's high-resolution full-frame cameras, this might not be a problem.

## ◐ I'm going travelling for six months and want to take a camera, not just my phone – what would a decent setup be?

Do you definitely need a camera for your travels? The latest camera phones are capable of some pretty amazing results, and thanks to some pretty nifty AI, you're no longer limited to a fixed focal length and good light to shoot in. If it's got to be a camera, a mirrorless interchangeable lens model would be a great choice, as this type of camera body is compact and relatively light in weight (compared to a DSLR), with smaller and lighter lenses, so you're not going to be weighing yourself down.

A good all-round setup would consist of a camera body and a couple of zoom lenses – I'd suggest something in the region of 18–55mm on a cropped-format sensor to cover wide-to-standard focal lengths, and something going from standard to telephoto, say 50–200mm. Don't forget to buy an extra battery or two, so you don't run out of power at a crucial moment, and take several memory cards (plus a laptop to backup your images). Although image stabilization is a common feature in cameras and lenses, you might also want to think about investing in a lightweight tripod for ultra-long exposures, night shots and selfies in exotic locations for your social media.

▲ A mirrorless cropped-sensor camera with a standard kit lens and an additional telephoto zoom would make a great travel companion – just don't forget extra batteries and memory cards!

▼ Camera phones are so advanced now that they make a pretty good substitute if you're caught without your camera.

# Lenses

Getting the right lens on your camera will make your photography a whole lot easier; get it wrong and it could be a costly mistake.

### ◉ Is there an ideal lens for shooting portraits?

Traditionally, a focal length in the region of 85–135mm (a 'mild' telephoto) was considered the classic portrait lens, as it allows a comfortable working distance between the photographer and subject and delivers largely distortion-free images. However, don't be afraid to experiment. Wide-angle lenses can create quirky distorted portraits, especially when taken to the extreme with an ultra-wide-angle or fisheye lens, while long telephotos can appear to bring the background closer and throw it out of focus for a shallow depth of field.

▲ This was shot in an ultra-compact space measuring just 2 x 1.2m (6 x 4ft), which was only just big enough for me to shoot with a 60mm focal length for a distortion-free portrait.

### ◉ Can you only use wide-angle lenses for landscape photography?

Not at all. Wide-angle lenses are great when you want to get everything into a shot, which is why they're often used to shoot landscapes, but they can also create quite empty shots if you're not careful, with large expanses of featureless space. Shooting a panoramic image or cropping your shot can often help in these instances, but another option is to use a longer focal length. Depending on how long you go, you can tighten up the frame to reduce the amount of featureless space, or pick out distant details in the landscape that help tell your story.

▶ For this distant view only a telephoto lens would do – in this case a 200mm focal length on a 35mm film SLR.

## Why do some zoom lenses cost a lot more than others, even though they cover the same zoom range?

This usually comes down to two things: the maximum aperture (and whether it is variable or constant), and lens-based image stabilization. As a rule, stabilized lenses cost more than non-stabilized ones, due to the additional technology, and faster lenses (see page 31), and those with a constant maximum aperture, also come at a higher price.

You may also find that some sort of special glass has been used in the lens design, which can also push up the price (and improve image quality), but this tends to go hand in hand with other technologies.

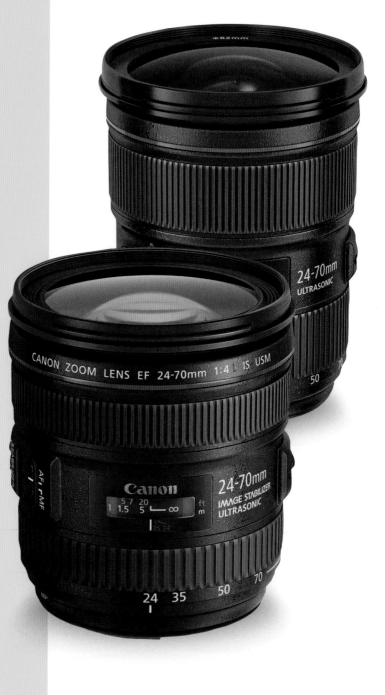

▶ Both of these Canon lenses cover a 24–70mm focal length. One has a maximum aperture of f/4 and image stabilization, while the other has a faster maximum aperture of f/2.8, and is roughly twice the price.

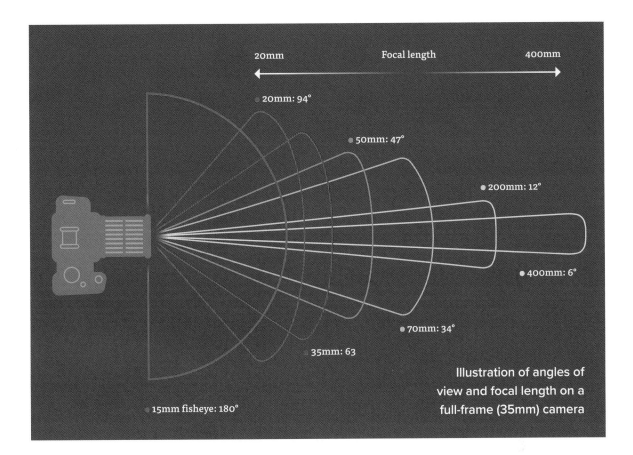

Illustration of angles of view and focal length on a full-frame (35mm) camera

20mm — Focal length — 400mm

- 20mm: 94°
- 50mm: 47°
- 200mm: 12°
- 400mm: 6°
- 70mm: 34°
- 35mm: 63
- 15mm fisheye: 180°

## ◎ What do people mean when they talk about an 'effective' focal length?

If you include smartphones and compacts, there's a bewildering range of sensor sizes used in digital cameras, and this affects the angle of view that any given focal length delivers. For example, a 24mm lens on a full-frame camera will give you a wide-angle view, but on a Micro Four Thirds camera with its smaller sensor it would be closer to a standard focal length, so the exact same focal length would deliver two very different images.

So, to try and create some sort of universal language and avoid confusion, photographers often refer to the 'effective' focal length, which is the focal length of the lens in relation to 35mm film or a full-frame digital camera. To find the effective focal length, the actual focal length of the lens is multiplied by the camera's

▲ Focal length indicates the angle of view of a lens, which is how much it 'sees'. With an APS-C or Micro Four Thirds camera, the smaller sensor's crop factor effectively increases the focal length and therefore narrows the angle of view.

crop factor, which is 1.5–1.6x for most APS-C sensors and 2x for Micro Four Thirds. So, a 24mm lens would have an effective focal length of 36–38mm on an APS-C camera or 48mm on a Micro Four Thirds camera, giving us a better idea of its effective angle of view.

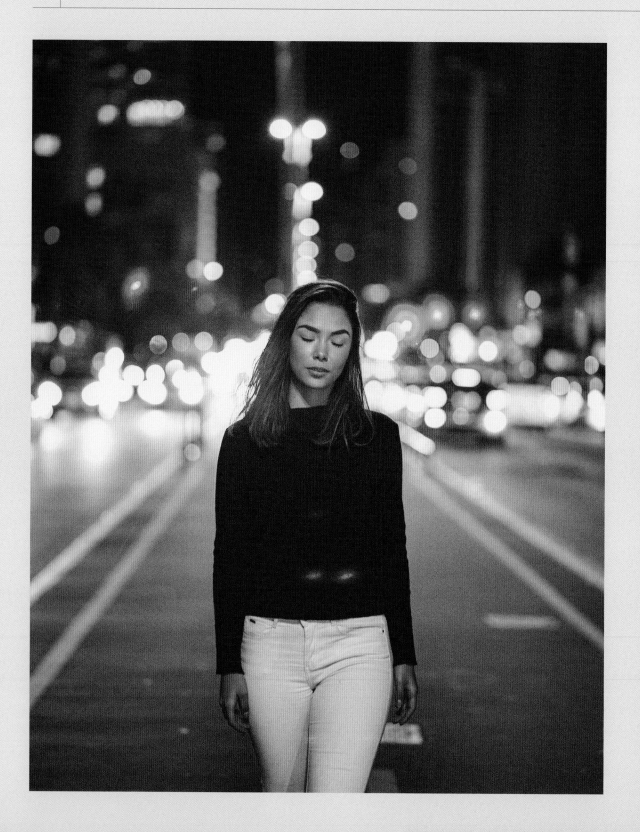

## ⚙ What the heck is 'bokeh'?

It's hard to take a picture today without someone commenting on its bokeh, but until maybe 15 years ago it wasn't really something that existed in photography. Or, more accurately, it existed, but it just wasn't talked about because it's so, well, insignificant. You see, bokeh refers to the appearance of out-of-focus points in an image. It's not about the subject – that thing that made you raise your camera to take a photograph in the first place – but blurred points in the background. Unfortunately, those blurred points have gained something of a cult following in recent years, with plenty of snappers out there sharing Insta-works that claim to demonstrate 'superlative bokeh', when they actually just show a shallow depth of field (the two are not the same), while others describe bokeh as if it's a measurable quality (I've lost count of how many times I've seen someone mention 'creamy' bokeh online). More often than not, bokeh is a near-inconsequential background element – nothing more, nothing less

◀ The appearance of bokeh – bright defocused points in the background of an image – is determined primarily by the design of the lens. A higher number of aperture blades will create a more circular shape.

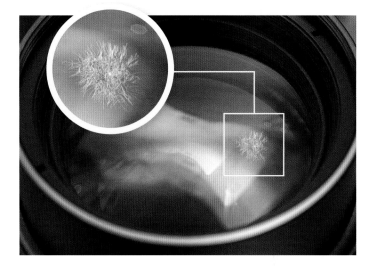

▲ Less than 12 months after I bought it, fungus started growing on one of the glass elements towards the front of this pre-owned lens. As it wasn't a particularly expensive purchase, getting it repaired professionally would be uneconomical, so I'll either have to live with it or try stripping it down and cleaning it myself.

## ⚙ I bought a used lens online and there's something that looks like a spider's web inside it, stuck to the glass – what could it be?

You would need to take it to a repair store to be sure, but it sounds like your lens has got fungus growing inside it. This is caused when dust that contains fungus spores gets into a lens, which is then (as most lenses are) stored inside a case or bag – the dark, potentially warm and possibly humid conditions create the ideal environment for fungus to flourish.

Although lenses can be stripped down and cleaned, this isn't always possible if the fungus is particularly aggressive, and it can also be an expensive repair. If you've got a warranty with the lens, the simple answer is to send it back and get a refund, but if not, you'll need to weigh up the value of the lens versus the cost of a repair – sometimes it's easier and less expensive to replace it. To try and prevent it happening to start with, consider storing your lenses in clear containers (so they aren't in the dark) with packets of silica gel to absorb any moisture.

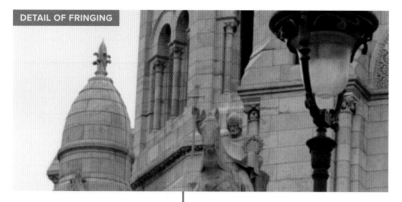

DETAIL OF FRINGING

▲ Fringing is typically found along high-contrast edges, and when zoomed in to 200 percent there are plenty of red and green fringes in this shot. It can usually be fixed quite easily though, as demonstrated on page 156.

## ◐ Why does my lens have two maximum aperture settings?

You'll only find this on zoom lenses, and it indicates that the maximum aperture changes depending on the focal length setting. So, if you were using a 18–105mm f/3.5–5.6 zoom lens, the maximum aperture would be f/3.5 at the 18mm end of the zoom, but would reduce to f/5.6 at an 105mm focal length, as the lens allows less light to pass through it. The reason this happens largely comes down to cost: it's easier and less expensive to build a zoom lens with a variable maximum aperture.

▲ I got this 18–105mm f/3.5–5.6 lens as part of a kit with my first cropped-sensor DSLR – it's pretty common for 'consumer' (and 'prosumer') zooms to have a variable aperture.

## ◐ What are the purple lines I keep getting along the edges in some of my photos?

Fringing, or chromatic aberration, is usually most noticeable along high-contrast edges in an image, particularly towards the corners of the frame. It's caused when a lens doesn't focus all of the different wavelengths of light at the same point on the sensor, creating a coloured fringe. A purple fringe can often be attributed to the microlenses on the sensor itself, while other colours indicate the camera lens is the culprit. Sometimes, shooting at a smaller aperture can make the fringing disappear, otherwise you can try and remove it when you process your pictures (see page 156).

## ◯ How can I stop lens flare ruining my shots?

The cause of flare is unwanted (non-image-forming) light getting into the lens and reaching the sensor, so you can try several things to prevent this light from getting in:

- Make sure your lens and any filters you use are clean, as greasy marks and dust are great at diverting light to where you don't want it.

- Shade the front of your lens so it's protected from that unwanted, indirect light. A lens hood is useful, but you can also shade the front of your lens with your hand, hat or newspaper. You could also try and shift your position so you're in shade – the main thing is that the front of your lens is shielded from as much lateral light as possible.

- Shoot with the light source behind the camera: if there's no direct light falling on the lens, there's no flare.

◄ Although flare is generally unwanted, it can also be used creatively. These plants were lit from behind, and I wanted to try and use the overall 'hazy' flare that was created by shooting into the light.

## ◯ I keep reading about people using 'fast' lenses, but what does that mean?

The 'speed' of a lens simply refers to its maximum aperture setting (see page 30). The wider the maximum aperture, the faster the lens, so a 50mm f/1.4 prime lens is faster than a 50mm f/2.8, for example.

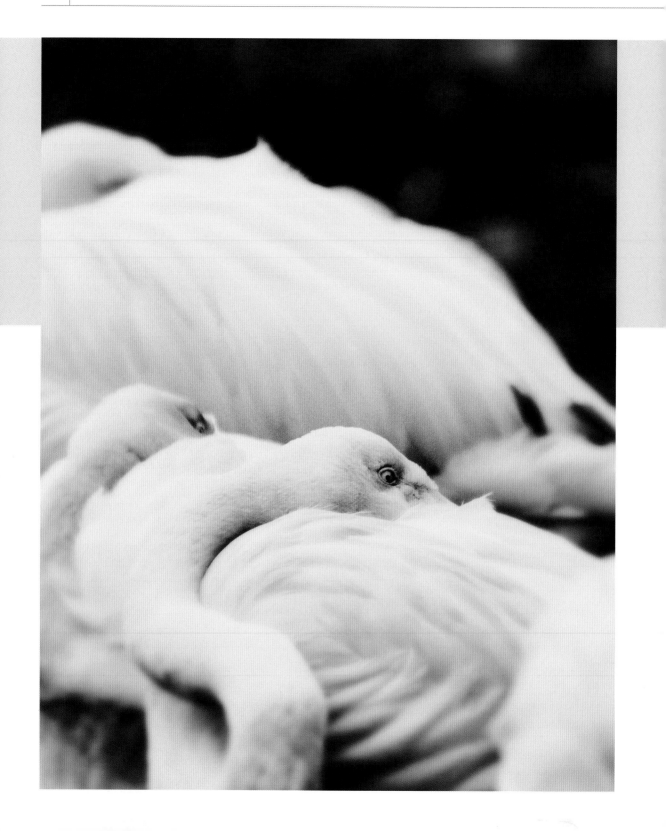

## What's the best lens for photographing wildlife?

The best lens for photographing wildlife is the one that's best suited to your subject, which comes down to a combination of factors such as subject size, how nervous it is and how close you can get to it. You will almost certainly need a telephoto lens, but smaller, nervous and distant subjects will require longer focal lengths than larger, less timid and closer ones. A telephoto zoom covering a number of bases makes a good starting point – 100–400mm, 150–600mm and 200–500mm zooms are popular choices – although many wildlife photographers use prime lenses such as 300mm, 500mm or 600mm. For greater reach you can add a teleconverter or extender: a 500mm lens with a 1.4x teleconverter effectively gives you a 700mm focal length, while adding a 2x teleconverter would give you 1000mm.

◀ Although this was taken at a local wildlife park, with captive birds, it still took a 450mm effective focal length to get this close to these flamingos.

## Can you use Canon lenses on a Sony camera?

Traditionally, with the exception of a few third-party lens makers, you would generally be tied in to using the lenses from the company that made your camera, so Canon lenses on Canon cameras, Nikon on Nikon and so on. However, it's now increasingly common for people to use lenses from one manufacturer on cameras from another.

You'll need an adaptor to connect the two, and may find that some or all of your camera's automation is lost (so be prepared to set your exposure and focus manually), but the plus side is that you can use a whole host of lenses that were previously unavailable to you.

▲ Thanks to the short flange focal distance on a mirrorless camera it's usually quite easy to get an adaptor that will let you use lenses from a different system – this full-frame Sony camera has been paired with a legendary Leica M lens.

There is one caveat, though: not all camera/lens combos will allow you to focus at infinity (the far distance), so you will be limited to close-up shots. The key is the flange focal distance (FFD), which is the distance from the front of the lens mount on the camera to the film/sensor. To maintain infinity focus, the FFD for the camera needs to be shorter than the FFD for the lens (based on the camera system it would normally fit). This allows an adaptor to be fitted between the two, so infinity focus can be maintained. Consequently, cameras with a short FFD and lenses with a long FFD offer the greatest flexibility in terms of potential pairings. This means cameras with a short FFD and lenses with a long FFD generally offer the greatest flexibility in terms of potential pairings. Mirrorless cameras have a huge advantage here, as they tend to have a very short FFD, while SLRs (and their lenses) tend to have a much longer FFD.

## ⟡ I took a shot and the horizon curves like a banana! What's going on?

Depending on the direction of the curve, what you're seeing is either barrel distortion or pincushion distortion. As its name suggests, barrel distortion causes straight lines to bow outwards (like the sides of a barrel), while pincushion distortion sees straight lines 'sucked in' towards the centre of your shot – the effect of both becomes more pronounced towards the edges of the frame. In either case, these distortions are caused by the lens, with wide-angle focal lengths associated with 'barrelling' and telephotos causing 'pincushioning'. You can minimize these effects by trying to avoid placing straight lines too close to the edges of the frame, or correct them when you process your images.

▲ Shot using a wide-angle lens, this seascape doesn't look too bad until you drop a straight line on the horizon – then you can see how the centre of the image is 'barrelling' upwards.

## ⟡ Can I use manual-focus film camera lenses on my digital camera?

Using old-school manual-focus lenses can be a great way of adding lenses to your collection without spending a heap of cash, but a lot depends on the make and model of your camera. Mirrorless cameras can be made to work with most lenses via an adaptor (see page 33), but DSLRs are fussier. Canon and Sony users will struggle, but Nikon and Pentax have backwards-compatible lens mounts that – with a few exceptions – allow you to use manual-focus lenses stretching back towards the birth of their respective SLR systems. However, it may not just be the focus that becomes manual when you shoot this way. You may find that your digital camera's metering doesn't work properly (if at all), and that you have to shoot in Manual mode. You certainly shouldn't expect to just 'point and shoot'.

▲ I spotted this lens at my local recycling centre, attached to a Nikon EM 35mm film SLR, and bought them both for less than a fiver. It might not be Nikon's best kit, but it works just fine on my full-frame DSLR.

◄ Prime lenses are great for portrait work, because they allow you to concentrate more on what's in the frame, rather than fiddling with the focal length. A wide aperture can come in use too, although for this shot I wanted a greater depth of field.

## ◎ Why do some photographers use prime lenses, but others prefer to use zooms?

It used to be that prime lenses offered sharper results than zooms, as it's easier to optimize a lens with only one focal length. Although that's still true to a certain extent – especially when it comes to all-encompassing superzooms covering 18–300mm focal lengths, or similarly extreme zoom ranges – the quality of some modern zooms is almost on a par with some primes,

so the decision now tends to come down to the maximum aperture on offer. This is often wider on a prime lens than a zoom, which can help you shoot in low light and create an ultra-shallow depth of field when you shoot with a wide open aperture.

# Other

There's a plethora of accessories you can add to your kit, but which ones do you really need?

## ⟡ Do I need filters for landscape photography?

Although they were once essential, there's now a very strong case for a lot of filters no longer being necessary for landscape work. It's easy to warm or cool an image by tweaking the white balance or making colour adjustments in your editing software, and graduated neutral density (ND) filters that were traditionally used to balance dark foregrounds with bright skies can now be re-created with much greater accuracy by blending different exposures.

The only possible exceptions are plain ND filters that extend exposure times, and polarizing filters that modify the wavelengths of light entering the lens, as neither of these effects can be achieved convincingly with software.

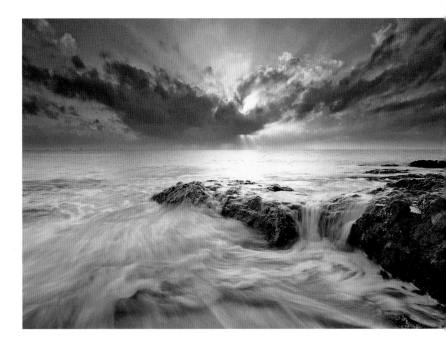

▲ Plain ND filters extend exposure times, allowing you to record moving elements such as water and clouds as a gentle blur.

▲ Digital editing and blending techniques can replace most of the filters a landscape photographer might use, but I still like to use graduated filters when I'm in the field.

### ✪ I bought a lens and was advised to buy a 'protection' filter – is this necessary?

There are two arguments here. The first is that putting any filter in front of your lens adds another surface that can trap dust, increase the risk of lens flare and/or simply degrade the image quality very slightly. In that respect, the fewer filters you have, the better your image will be. At the same time, though, that filter will protect the front element of your lens from scratches and overzealous cleaning, which could also lead to degraded images.

Personally, I'd rather replace a filter than a lens, so I'd be inclined to go with the added protection – just make sure you buy a high-quality filter, not a bargain-basement one that compromises your image quality.

▼ Which would you prefer: a filter like this that can be removed and replaced relatively cheaply, or a lens with the same damage to its front element? I know which one I would choose...

### ✪ I've got a screw-in filter stuck on my lens – how can I remove it?

You might get lucky by trying to unscrew it while wearing a rubber glove, as the additional friction can often be enough to get that little bit of extra purchase needed to twist it free. Putting a rubber band around the filter and trying to turn it with your bare hand has a similar effect, and if that doesn't work, a dedicated filter wrench will give you more leverage. In any case, what you *don't* want to do is try and prize the filter off, attack it with pliers or spray it with any type of releasing fluid – these are all surefire ways of damaging the filter (if you're lucky) or the lens (if you're not).

▲ My first tool for removing stuck filters is a rubber glove – the extra resistance it gives you is often all that is needed.

### ✪ How can I clean my filters?

A blower brush (see page 39) is great for removing loose dust, followed by a couple of drops of lens-cleaning fluid and a wipe with a microfibre cloth. Make sure the cloth is cleaned regularly, though, so it doesn't add more grease than it removes or hold on to particles that could potentially mark your filters.

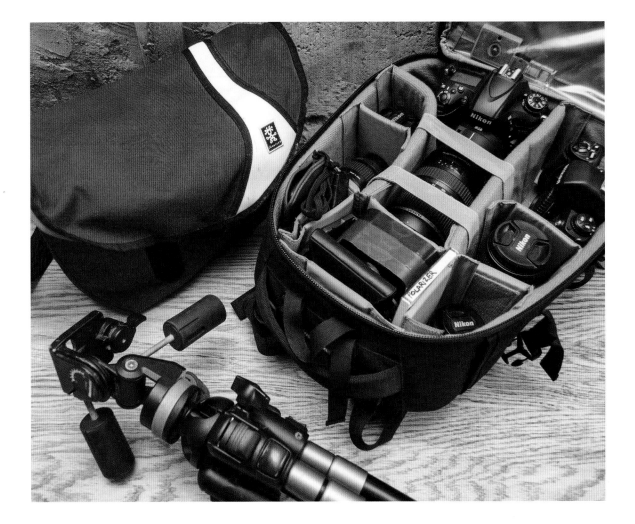

## ⊙ Which is better for carrying my camera gear: a backpack or a shoulder bag?

If you're trekking through the wilderness then a backpack would get my vote every time – ideally something with enough space for your camera gear and your personal bits and pieces (jacket, water, keys, phone and so on). However, if you're pounding the pavement or stalking the sidewalk as a street photographer, a bag that you can sling over your shoulder will typically give you quicker and easier access to your kit, letting you swap out lenses when you see a scene unfolding in front of you. In either case, pick a backpack or bag that has room for your kit to grow — you don't want to buy a new lens in a few months' time and find you have to upgrade your bag as well.

▲ I'll use a backpack to carry my gear if I've got to walk to a landscape location, but a shoulder bag with a padded camera insert for street shooting.

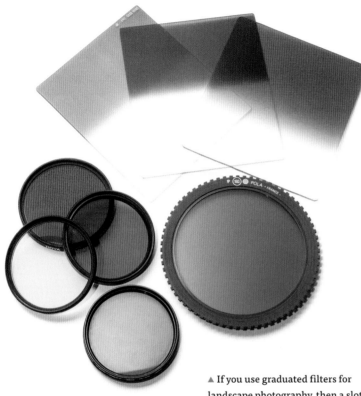

▲ If you use graduated filters for landscape photography, then a slot-in system is essential, but with most other filter types, it's your call.

## ○ Which filter system is better – screw-in or slot-in?

With some filters it doesn't matter – if you're using a plain, coloured filter for black and white photography, for example, either filter system will work just as well. In other instances it does make a difference, though, and if you're using graduated filters, a slot-in system is preferable as it allows you to rotate and align the filter.

Slot-in filters can also be more cost-effective if you've got several lenses with different diameters, because you only need to buy different adaptor rings to use the same filters on each lens, rather than buying multiple filters. Of course, there's nothing to stop you from using both types of filter together – I prefer to use screw-in polarizing filters, for example, but have a slot-in system for graduated filters, and regularly use the two together.

## ○ What's the best way to clean a lens?

Everyone has their own method for cleaning their lenses, whether it's using the corner of their T-shirt (not recommended) to using a dedicated cleaning kit. Personally, I use a 'dry' cleaning approach, with a blower brush to get rid of any loose dust, and a lens cleaning pen with a coated tip to remove greasy smears. However, I've also used a variety of 'wet' cleaning methods in the past, from cleaning cloths and lens-cleaning spray from my local optician to optical wet wipes. Whatever method you use, the bottom line is the same: clean lenses always produce better photographs.

▲ A blower brush is ideal for removing dust, but for greasy fingerprints I'll use a LensPen – wet cleaning wipes are generally a last resort.

### ⟳ I love the look of drone shots, but don't want to spend a lot of money on something I might not use that much — is there an affordable 'way in' to drone photography?

The easiest (and perhaps best) way into drone photography is to get yourself an inexpensive 'toy' drone to practise flying with. The biggest challenge you'll face is getting to grips with the flight side of things and a low-cost drone will teach you the basics just as well as a larger model, but without the expensive repair bills if something goes disastrously wrong. There are plenty of low-cost, camera-equipped models to choose from and once you've nailed the basics you can graduate to a bigger and better flying machine.

◀ ▲ A high-spec, high-resolution camera drone will definitely get you great aerial images, but if you're not sure drone photography is for you, it could also be an expensive folly.

▲ A low-cost 'toy' drone with a built-in camera will let you practise your flying and see how much you enjoy drone photography. If you like it, you can upgrade, but if not, you haven't spent a lot of money finding out.

## What should I look for when I'm buying a flash?

First off, make sure it's compatible with your camera. Buying a flash unit that's the same make as your camera is a good starting point, but it also helps if they're a similar age – newer flashes may not always work to their full potential with older cameras, while older flashes may prevent the camera from delivering everything it is capable of. There are also third-party manufacturers who produce flash units with similar technologies to those offered by the camera makers.

With compatibility out of the way, you can think about the flash itself. A tilt-and-swivel head is a very attractive feature (I'd say essential), as it will let you bounce the flash off a ceiling or wall to soften the light. Doing this will mean the light has to travel further, though, so you will need to consider the power of the flash as well. This is usually given as a guide number (GN), and the higher the rating, the more powerful the flash. Other useful features can include an automatic zoom head that will match the spread of the flash to the angle of view of your lens; wireless control, which will let you use the flash away from your camera with point-and-shoot simplicity; and a high-speed Sync mode that will let you use the flash with fast shutter speeds (outdoors on sunny days, for example). If your style of photography is particularly flash-heavy, then a model that can be hooked up to a portable battery pack could also be useful.

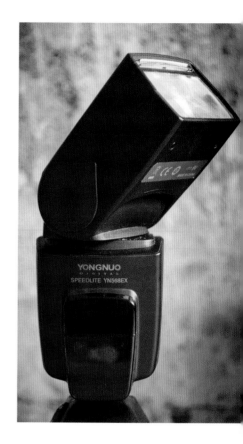

▶ Through the Lens (TTL) control, a tilt-and-swivel head, decent power output and a zoom head were four things I was looking for when I was buying a hotshoe flash. My budget led me to this third-party option from Yongnuo.

## Can I use an old manual flash from a film camera with my digital camera?

You sure can, but be very careful before you slide it into your camera's hotshoe, as different flashes have different trigger voltages. In the days of relatively 'simple' film cameras this wasn't something anyone thought twice about, but digital cameras are crammed full of delicate circuitry, and it's possible to fry your camera's brain if the trigger voltage on the flash is higher than the camera's.

There is an easy workaround, though: buy a PC hotshoe adaptor. The PC in this instance is short for 'Prontor-Compur' (it has nothing to do with computers), and is the standard electronic flash socket that's been in use since the 1950s. Although it was a standard feature on film cameras, most digital cameras don't have a PC socket built in, which is why you need a PC hotshoe adaptor (and the relative sync lead to plug in the flash). The low-cost adaptor simply slots into your camera's hotshoe, providing you with a PC socket that will trigger your manual flash, while at the same time protecting your camera's circuit boards.

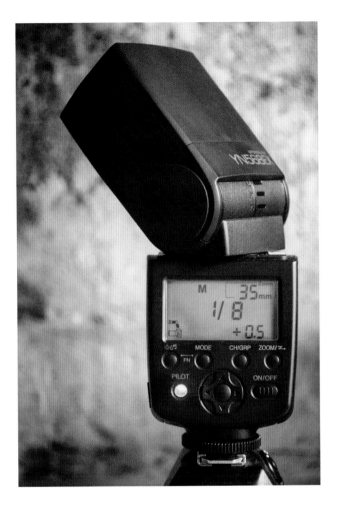

## ◉ Should I use the fastest, highest-capacity memory card I can get?

If you primarily shoot video, there's a strong argument for using fast, high-capacity cards because video creates extremely large files. So, having the speed to read and write those files, and the capacity to store them to start with, is not only useful, but sometimes essential. However, with still photographs it's not quite so important, unless you're using a high-resolution camera (say, 35+ megapixels) and need to shoot continuously (for sports and wildlife, for example).

In other situations, the need to read and write data quickly doesn't necessarily matter so much, so you could perhaps opt for a slower (and less expensive) card. It's also worth remembering that memory cards can sometimes fail without warning, potentially losing their contents in the process, which is why some photographers – myself included – would prefer to use several smaller-capacity cards rather than saving everything to a single high-capacity card.

▶ The key to using an old flash safely on a digital camera is a PC hotshoe adaptor, which sits between the flash and the camera, providing an old-school flash sync socket. All you then need is a lead to connect the two (not shown here).

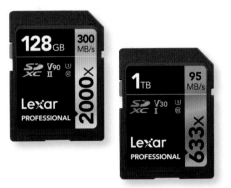

▲ Choosing a memory card often means balancing speed with capacity: the 128GB Lexar card shown here is exceptionally fast, but while the 1TB card is slower, it has a much higher capacity.

## ◐ Do I have to buy a tripod and head from the same manufacturer?

Absolutely not. The majority of tripod legs and heads use the same screw (3/8-16) to connect them, which means they're fully interchangeable. You can use a Manfrotto tripod head on Benro legs just as easily as you can pair your 3 Legged Thing legs with a Giottos head. In this way, you can create your own perfect partnership, or swap out one part of the system at a later date, without having to change the other.

## ◐ What's the difference between SD, SDHC and SDXC memory cards used in cameras?

At a glance, there's not much that differentiates any of the full-size Secure Digital (SD) memory cards, other than their label, but internally it's a different story. What separates them most is their storage capacity: the original SD cards (now sometimes called SDSC for 'Standard Capacity') have a maximum capacity of 2GB; SDHC ('High Capacity') extends this to 32GB; SDXC ('eXtended Capacity') takes the maximum potential card size up to 2TB; and we now also have SDUC ('Ultra Capacity') cards that can support up to 128TB. Broadly speaking, digital cameras that use SD cards are usually backwards compatible to a certain extent, so new cameras can use some (but not always all) of the older SD formats. However, older cameras are usually limited to the SD technology that was available when the camera was produced, so may not be able to take advantage of newer cards.

◀ They might look the same and fit the same cameras, but you wouldn't get far today with a 'standard' 32MB SD card.

## ◐ Why do some tripods come with a head attached, while others don't?

In a word: versatility. Tripod legs and heads come in all weights and sizes, but what's ideal for one photographer might be a compromise for another. Perhaps the tripod legs don't go high enough, or low enough, or hold enough weight? Maybe a ball head isn't accurate enough, or a pan-and-tilt head is too slow, or you want the ultra-precise adjustments offered by a geared head? There's rarely a one-size-fits-all solution, so while a tripod with a fixed head is better than nothing, most photographers would rather create their own bespoke combination of legs and head.

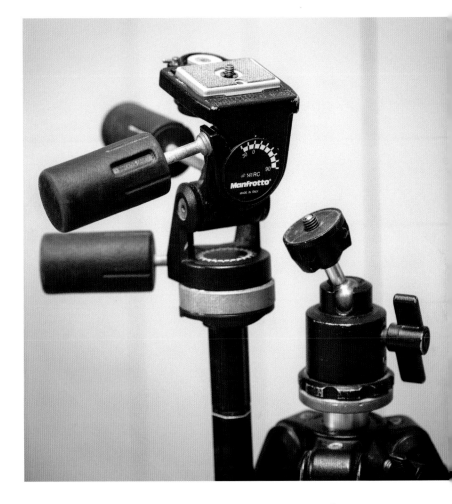

### ◌ What are the advantages of a ball head over a pan-and-tilt head for a tripod?

As a rule, it's far quicker to position your camera with a ball head because there's usually just one control that locks and unlocks the free-moving ball. So you can quickly switch from portrait to landscape shooting, for example, and have complete freedom to fine-tune the camera position. However, this is also their weakness, because it means it's harder to make precise adjustments in one plane – if you want to turn the camera slightly to the left, there's nothing stopping you from nudging it up or down at the same time. And that's ultimately the difference: a ball head offers speed over absolute precision.

▲ I've had the same pan-and-tilt and ball heads for over 20 years now, but it's the pan-and-tilt head that sees the most action.

### ◌ Do I need to use a tripod if my camera/lens has image stabilization?

Although you can get maybe 5 or 6 stops of stabilization from camera- and lens-based systems, 1/15sec. is still about the slowest shutter speed I'd use for camera-shake-free handheld shooting. However, as high ISO settings are increasingly producing noise-free (or at least noise-acceptable) images, reaching that speed threshold takes longer than it used to, so for general shooting a tripod is certainly less essential than it once was. There are times when it still cannot be beaten, though, such as when you want to precisely frame a scene, shoot long exposures, or take multiple shots to focus stack (see page 72) or create a panorama or HDR image.

# IN THE BEGINNING

Exposure, focus and colour are at the heart of every photograph you take – get those right and you'll be well on your way to shooting success.

# Setting up

Setting up your camera correctly will help you avoid any potential pitfalls.

## ◌ Should my camera be set to Raw or JPEG?

This initially comes down to what you want to do with your images after you've shot them. If you want to shoot and then print or upload your photos straightaway, then shooting JPEGs is the answer. You can influence the look of the image in-camera, using picture styles to change the contrast, saturation, sharpening and so on, and you'll have an image that can be posted online or printed without any further intervention.

However, if you like to make changes to your photographs on a computer or tablet (or even within the camera itself in some instances), shooting Raw is a better option. This is because a Raw file offers much more processing flexibility and the changes you make are reversible, so there's greater freedom to experiment with your shots without permanently losing image quality. Raw files also have a greater 'bit depth' than JPEGs, which means they can record a greater number of colours. Put simply, a Raw file is the best possible image that your camera can deliver. The downside is that you must process your images before you do anything else with them: you can't upload a Raw file to Instagram, for example, and online labs won't be able to print from them directly. If you're still not sure which

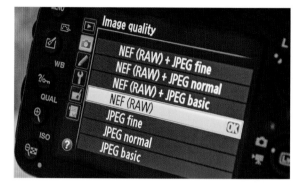

▲ I generally shoot Raw because I often process my images quite heavily – about the only time I shoot JPEGs is if I'm photographing something to sell on eBay.

one's for you, a lot of cameras let you shoot Raw and JPEG simultaneously. This takes up more space on your memory card, but means that you get the best of both worlds — a ready-to-use JPEG and an ultimate-quality Raw file to process later on.

## ◌ My camera has several 'shot size' options, with different resolutions – which one should I use?

Unless you have a very good reason to shoot at a reduced size, such as photographing exclusively for a website, shoot the largest image sizes you can. Although you can resize your photographs on your computer (or in-camera in some cases), if you enlarge a shot your software will have to add pixels that didn't exist before, which is a surefire way to reduce the quality of your shots.

▶ No matter what I'm shooting, or what I intend to do with the shot, I'll always have my camera set to shoot at its highest resolution. Why? Because it's easier to remove pixels and downsize an image than it is to add them.

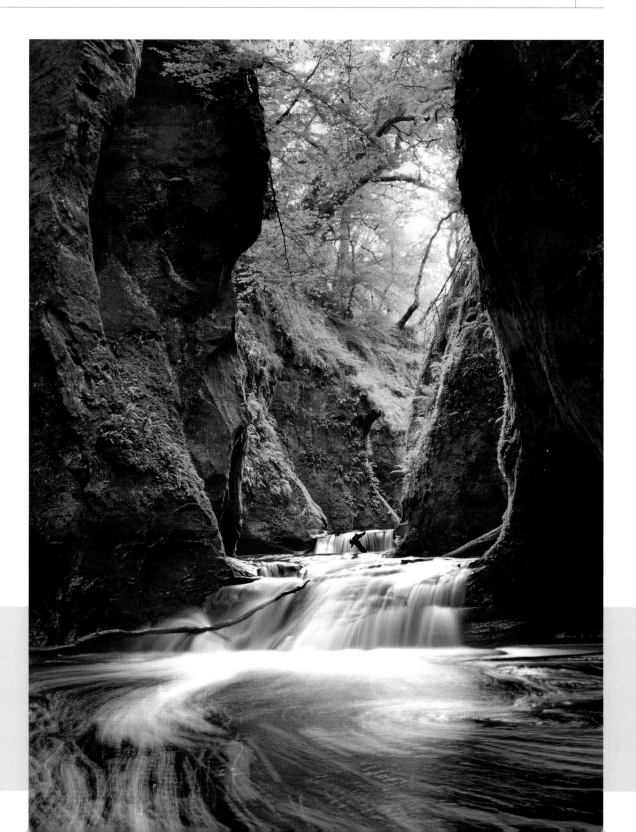

## ◌ Should I use my viewfinder or the rear screen when I shoot?

Personally, I tend to use the viewfinder, as it lets me focus entirely on what I'm shooting, without any distractions – it gives me literal and metaphorical tunnel vision. An exception to this is if I'm shooting a still life with the camera on a tripod, when I'd much rather have a large preview image with the option to zoom in and set/check focus, so I'll switch to the rear screen instead. When it comes to landscapes, I use the viewfinder and rear screen in tandem, peering through the viewfinder to find my shot (the tunnel vision effect), and then using the rear screen to fine-tune things and nail the focus. So, which one you use may boil down to what you are shooting, and even then it might not be an either/or choice.

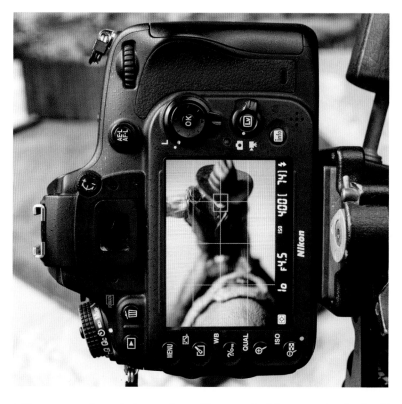

▲ The rear screen is great when you're working on a tripod, but remember that it will drain the power more quickly than using your camera's viewfinder.

## ◌ Do I need to do anything to my memory card before I use it?

Although a memory card is 'empty' when you buy it, you should always format it in your camera before you use it for the first time. This will ensure that the card is set up with any folders and files that the camera expects to see, minimizing the risk of problems further down the line. I'd also recommend formatting your memory cards every time you use them, so you're starting with a 'fresh' card every time – just make sure you've downloaded any images that are on it first.

▲ Formatting your memory card prepares it for use in the camera and reduces the risk of images becoming 'corrupt'.

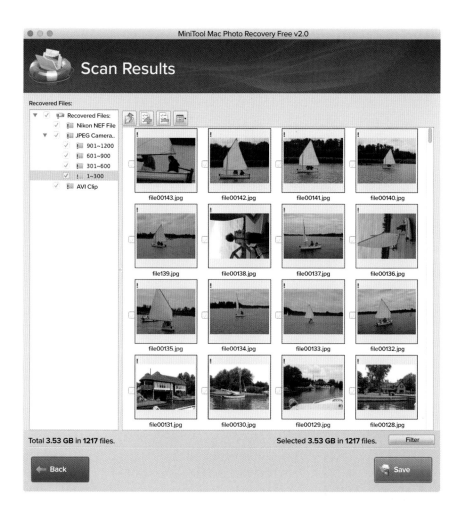

◀ I ran the free MiniTool Photo Recovery app on a memory card that has been formatted countless times in a compact camera. Despite the card saying it only had 15 images saved to it, the app managed to find over 1,200 files, including photos that were shot more than five years ago!

## ✦ I formatted my memory card, but hadn't downloaded the pictures – is there anything I can do?

This has happened to us all at some point, but the good news is that all may not be lost. With a lot of cameras, the only thing that's deleted when you format your memory card is the File Allocation Table (FAT), which essentially organizes your image files on the card so your camera and computer can see and read them. When the FAT is deleted (and a new, empty one created in its place), the photos on your card look like they've been erased, but the actual image data stays on the card.

The data is only lost when you overwrite it by shooting more photographs, so as long as you haven't shot anything else there's every chance that a file-recovery app or utility will be able to delve into your seemingly empty memory card and extract your images.

Premium memory cards often come with just such a program, and there is also a wide range of free software available. If those don't work, there are also paid-for programs that tend to be a little more powerful, and professional recovery services, although how much you spend will largely depend on how valuable your shots are.

# Exposure

**Getting the exposure right is arguably the most fundamental skill that any photographer needs to learn.**

▲ Whether you're using Live View to shoot or reviewing your images, the ambient light levels can make a big difference to how images on your camera's rear screen appear, so it shouldn't be seen as an accurate guide to exposure.

### ◎ My photos look okay on the back of my camera, but on my computer they're too dark – why is this?

Using your camera's screen as a guide to exposure is never a good idea, as there's just no way of telling how accurate the screen is. For a start, the brightness on most screens can be adjusted (and on some screens this is done automatically based on the ambient light), so while your image might look okay on screen, it could be that the brightness has been cranked up, which is why the image appears much darker on your computer.

The conditions you view the screen under can also impact how bright your photographs appear: if you're shooting at night, your screen images will look really bright, but outdoors on a sunny day the screen image can appear a lot darker. The upshot is that it's hard to gauge whether your shots are too bright, too dark or just right based on the screen alone.

There is a solution, though: your camera's histogram. This is a graph that shows you where the tones in an image fall. If the graph shifts to the left, it means an image consists of dark tones. If it's a photograph of a dark subject, that's to be expected, but if you're photographing a bright subject it would mean the shot is underexposed. Conversely, if the graph shifts to the right, it means your shot contains a lot of bright tones, which is either because you're photographing a bright subject or because your shot is overexposed. As a histogram is generated from the image data, it doesn't matter how bright or dark your screen is – you're getting an objective overview of the exposure and can tweak things accordingly.

## ⚙ Why are my photos too light?

When your photos are lighter than you expect them to be it's because the sensor has received too much light, so the shot is overexposed. If you're using one of your camera's automatic shooting modes (Program, Aperture Priority or Shutter Priority), you can dial in some negative (–) exposure compensation to reduce the exposure before shooting again. However, if you're in Manual mode, you'll need to close down the aperture, use a faster shutter speed or set a lower ISO to compensate.

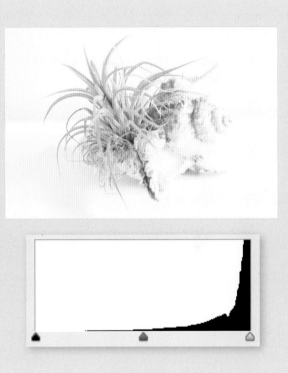

▶ An overly bright image means the sensor has received too much light. The histogram for this shot is crashing off the right end of the graph, which means the brightest areas have been 'clipped' and are pure white. No amount of processing will bring back detail in those parts of the image.

## ⚙ Why are my photos too dark?

Dark or underexposed photos are the opposite of overexposed images: they are the result of your sensor not receiving enough light. Depending on the shooting mode you're using, you will need to either apply positive (+) exposure compensation, select a wider aperture, use a slower shutter speed or set a higher ISO to brighten things up when you shoot again.

◀ There's a big gap at the right end of the histogram for this exposure, which means the brightest areas are grey, not white. However, the histogram fits within the graph, which tells me all of the tones in the subject have been recorded, so it will be possible to 'fix' the shot, as outlined on page 155.

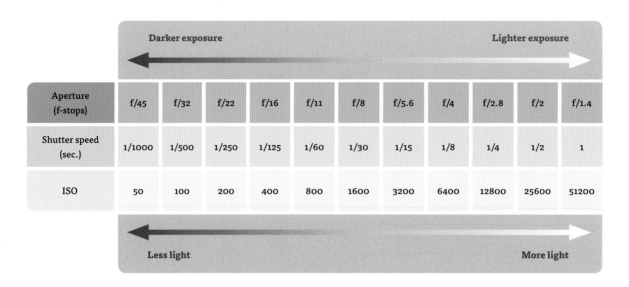

| | Darker exposure → ← → Lighter exposure | | | | | | | | | | |
|---|---|---|---|---|---|---|---|---|---|---|---|
| **Aperture (f-stops)** | f/45 | f/32 | f/22 | f/16 | f/11 | f/8 | f/5.6 | f/4 | f/2.8 | f/2 | f/1.4 |
| **Shutter speed (sec.)** | 1/1000 | 1/500 | 1/250 | 1/125 | 1/60 | 1/30 | 1/15 | 1/8 | 1/4 | 1/2 | 1 |
| **ISO** | 50 | 100 | 200 | 400 | 800 | 1600 | 3200 | 6400 | 12800 | 25600 | 51200 |

Less light ← → More light

▲ Whether it's the aperture, shutter speed or ISO, a full 'stop' – as shown here – refers to the same thing: a halving or doubling of light compared to the stop either side of it. In this way, stops form a common measure of exposure.

## What are 'stops'?

In photography, 'stops' are the currency of exposure. In the simplest sense they refer to the halving and doubling of light, using either the aperture, shutter speed or ISO, where each halving or doubling step is equal to 1 stop.

For example, if you reduce the shutter speed from 1/250sec. to 1/500sec., you halve the amount of light getting to your sensor, which is a 1-stop adjustment; halve the shutter speed again (to 1/1000sec.) and you will have adjusted the shutter speed by 2 stops. The same principle applies when you extend the shutter speed: doubling the exposure time means doubling the amount of light, which is 1 stop. With ISO, doubling or halving the ISO value – from 400 to 800 – is also a 1-stop change (we'll look at aperture and f-stops in more detail on page 62).

In a practical sense, what this means is that stops give you one unit of exposure that applies equally to aperture, shutter speed and ISO. Say, for example, that you wanted to change your shutter speed from 1/30sec.

to 1/125sec. to avoid camera shake. This would decrease the exposure by 2 stops, which would make your photo darker, so to maintain the same overall brightness you would need to make a 2-stop adjustment in the opposite direction. You could do this using the aperture (opening up the aperture from f/11 to f/5.6, for example), or the ISO (perhaps changing it from ISO 100 to ISO 400), or by making changes to both the aperture and ISO (a 1-stop adjustment to both would make a 2-stop change overall). For even greater precision, most cameras allow you to change your exposure settings in ½- or even ⅓-stop increments, but the same rules apply: ⅓ stop on your aperture is exactly the same as ⅓ stop on your shutter speed and ISO.

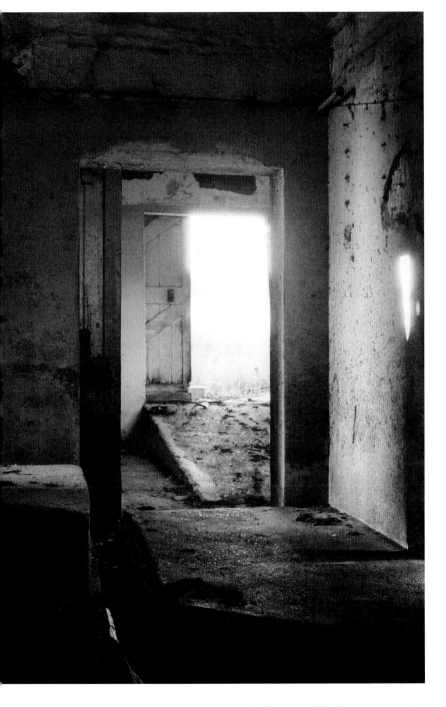

## ◌ When would I need to use spot metering?

Although multi-area metering has made center-weighted metering redundant, spot metering is still incredibly useful. It's particularly helpful when you find yourself shooting in tricky lighting situations that might 'fool' multi-area metering into under- or overexposing a shot (as is the case with snow, as outlined on page 127). In these situations, spot metering will let you target a very small mid-tone area in the scene, so you get an accurate exposure – the pavement, a rock and sunlit grass are all pretty good mid-tone options. Then, you can either dial your exposure in manually (using M mode) or use your camera's Auto Exposure Lock (AE-L) button to 'set' the exposure while you reframe and shoot. The mid-tone you targeted will be exposed as exactly that – a mid-tone – while the highlights and shadows will fall naturally into place, without influencing the exposure.

▲ I shot this on film using a camera that only had center-weighted and spot metering options. I didn't trust the center-weighted option to get things right with such an extreme bright patch in the middle of the frame, so I switched to spot metering, took a reading from the wall on the right, and set the exposure manually.

## When would I need to use center-weighted metering?

Center-weighted metering used to be the only option on a lot of manual film cameras, but it's now been joined by more sophisticated multi-area metering patterns. These newer metering options are so sophisticated that it's hard to imagine if or when you'd need to use center-weighted metering instead – about the only time I use it is when the film camera I'm shooting with doesn't have any other option.

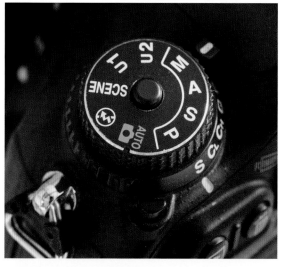

## ⟳ What does PASM stand for?

PASM is an acronym of the four key shooting modes on DSLR and mirrorless cameras: Program, Aperture Priority, Shutter Priority and Manual. They each allow you to set the aperture and shutter speed in different ways, be it taking full control of both (Manual), selecting one and having the camera choose the other (Aperture and Shutter Priority), or giving the camera control, but with the option of intervening when you want (Program). Which mode you use most will largely come down to what you photograph and how.

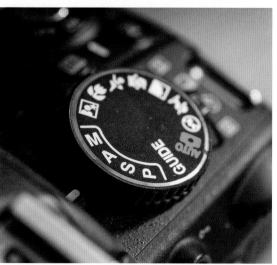

◀ Whether you use an entry-level DSLR, mirrorless or a high-end pro-spec one, the PASM quartet gives you the same four shooting modes.

## ⟳ What's the difference between Program and Auto?

In both of these shooting modes, the camera will take control of the exposure for you and choose what it thinks is the best combination of aperture, shutter speed and ISO for your shot. In Auto you have little (if any) control over anything else, including metering modes and focusing. However, switch to Program and you can take back a bit more control. For a start, the camera only sets the exposure, so you can change focus modes, metering patterns and so on. You can also choose the ISO, rather than relying on Auto ISO (although that remains an option). Most importantly, though, you can adjust the paired aperture and shutter speed suggested by the camera so you can get a little bit more creative. For example, if the camera was giving you an exposure of 1/60sec. at f/8, but you wanted a shallow depth of field, you could shift the exposure to 1/250sec. at f/4.

Alternatively, you could shift the exposure in the opposite direction to benefit from a slower shutter speed that introduces motion blur, and a smaller aperture and increased depth of field. In either case, the aperture and shutter speed are altered in tandem (you don't get to control them independently), so the same overall exposure is maintained.

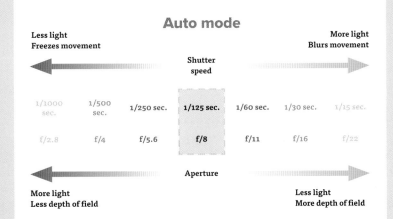

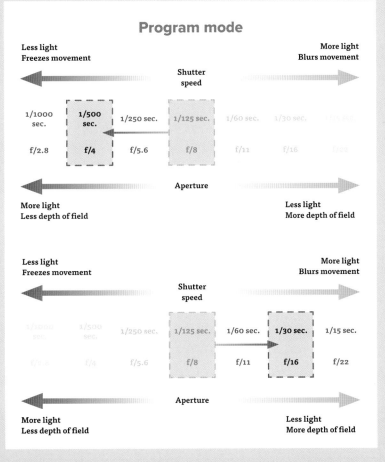

▲ When you shoot in Auto, the camera decides on the aperture and shutter speed and that's what you shoot at. With Program you can shift the paired setting so you have a little more creative control.

## ⬡ Which is better, Aperture Priority or Shutter Priority?

You may as well ask if apples are better than oranges, because it's not really a case of one being 'better' than the other – they both have an equal place in the fruit bowl. As the names suggest, choosing one of your camera's Priority modes largely comes down to whether setting the aperture or shutter speed is most important to you.

If you're shooting sports or some other fast-moving subject, then selecting a fast, action-freezing shutter speed is usually the most important thing, in which case Shutter Priority will let you dial in your preferred speed – 1/1000sec. perhaps – and the camera will pick an aperture to suit. However, if you're shooting portraits and want them all to have a shallow depth of field, you may want to switch to Aperture Priority, set a wide aperture (f/2.8, for example) and let the camera sort out the shutter speed. In either case, you choose the setting that's most important to your shot, and the camera picks its partner.

APERTURE PRIORITY

SHUTTER PRIORITY

◀ ▲ Which Priority shooting mode you choose will largely depend on what is most important to you: controlling the depth of field or controlling the appearance of movement in your shot.

**BRACKET -2 STOPS**

**BRACKET +2 STOPS**

**BRACKET 0 STOPS**

◀ I was shooting towards the setting sun (just left of frame) and knew I wouldn't be able to get the lovely bright, hazy foreground and colour in the sky in the same exposure. So, I took a bracketed sequence at 2-stop increments to blend together – see page 158 to see how it went.

## ⬡ What do photographers mean when they talk about 'bracketing' exposures?

Exposure bracketing means taking several shots of the same subject, each at a slightly different exposure setting, with the idea being that one of the exposures will be spot-on. This can be handy if you're shooting in tricky lighting conditions and aren't entirely sure what the right exposure is, especially if you're shooting JPEGs, which aren't processed in the same way as Raw files (with Raw files a small amount of exposure adjustment can be applied when you process the image on your computer).

Most cameras have an automatic bracketing feature (often abbreviated to AEB) that will let you choose how many shots you want in your bracketed sequence, and how much of an exposure difference you want between them. For general shooting, three exposures set 1 stop apart is usually enough, but in more extreme conditions you might want to shoot a higher number of images with a bigger gap between them – when creating HDR images, for example.

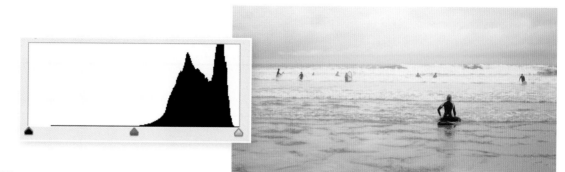

▲ ▶ When you 'expose to the right' you need to keep a close eye on the histogram: the graph should be as far to the right as possible without clipping the highlights. When you process your image you bring the bright tones back to 'normalize' the exposure, using Levels, Curves or Exposure and Highlight/Shadow controls. It's up to you how you do it, but as you can see here, it's surprising how much (noise-free) detail can be drawn out from the bright areas.

IMAGE AS SHOT

PROCESSED IMAGE

## ◎ I heard someone mention 'ETTR', but what does it mean?

ETTR stands for 'Expose to the Right', which is an exposure method designed to minimize noise in digital photos. The theory is simple, but slightly counterintuitive: instead of setting the correct exposure, you are aiming to make the exposure as bright as possible, but without clipping the highlights. This means the image will usually look too bright and its histogram will be shifted as far to the right as it can be (hence 'expose to the right'), but without going off the graph. Dialing in positive exposure compensation is one way of achieving this, or you could bracket your exposures. In any case, the second part of the process is to 'normalize' your image when you process it, which basically means darkening it down to correct the exposure.

But why would you bother going through this convoluted process when you can just set the right exposure in camera? The answer lies in the signal-to-noise ratio. At any given ISO setting, the lowest amount of noise is in the brightest parts of the image, because these are the areas on the sensor that receive the most light, and it's light that forms your photos. So, when you expose your images so they're as bright as possible, what you're doing at the camera's sensor level is maximizing the signal-to-noise ratio and ensuring your shots have the lowest possible levels of noise in them. Darkening them during processing doesn't increase the noise at all (unlike lightening a dark image, which will), so you end up with the 'optimum' image.

# ✦ So... what's the signal-to-noise ratio?

Every digital image is made up of two things: an image-forming signal created by light reaching the sensor, and a certain amount of unavoidable noise created by the various electronics within the camera. You might not see the noise, but it's there.

The signal-to-noise ratio – or SNR to give you yet another photographic acronym – indicates the amount of signal you've got in relation to the amount of noise. A low SNR means that the two are pretty similar, so you may have as much noise as you've got signal (image). The result will be a photograph where subject detail gets lost in the background 'noise' which is basically what happens when you set your camera's highest ISO setting or use ultra-long exposures. However, when you've got a high SNR, you're getting plenty of that lovely image-forming signal, and a lot less of the distracting noise, so images are sharp and detail-rich.

Using the lowest ISO setting you can is a very simple way of making sure you're not compromising your SNR, as is avoiding exceptionally long exposure times. You can also expose to the right, or perhaps even use exposure-stacking techniques – these are particularly popular with astrophotographers when it comes to combating long-exposure noise.

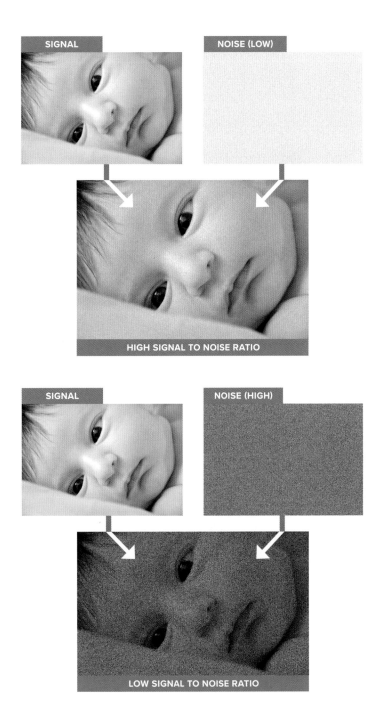

▲ Digital photographs consist of a 'signal' (the image) and non-image-forming 'noise'. The respective level of each determines the SNR – a low SNR will produce a noisy image, while a high SNR will be far 'cleaner'.

# Aperture

The aperture not only controls the amount of light that can pass through a camera's lens, but also has a major impact on the look of your shots.

## What are f-numbers?

Of all the terms associated with photography, f-numbers – or, more accurately, f-stops – are perhaps the most confusing. Your lens will have a range of f-stops, perhaps running from f/4 to f/22, and these indicate the size of the aperture (the opening in the lens) that lets light through: the bigger the opening, the more light passes through the lens, and the brighter the exposure. The confusion usually arises because small f-stop numbers (such as f/2.8 and f/4) indicate a wide aperture, so a big opening that lets a lot of light through, whereas big f-stop numbers (such as f/16 and f/22) indicate a small aperture or opening that allows less light to pass through, so it pays to remember the mantra 'big number, small hole' (or 'small number, big hole', if you prefer). The full range of f-stops is shown below.

As the name suggests, each full f-stop (or 'stop' – see page 54) allows half as much light to pass through as the one before it, so f/8 lets half as much light through as f/5.6, f/11 lets half as much light through as f/8 and so on. If you go in descending order, apertures let in twice as much light, so f/8 allows twice as much light through as f/11, for example. So, controlling the f-stop on your lens lets you control your exposures, allowing more or less light to pass through the lens and reach your film or sensor.

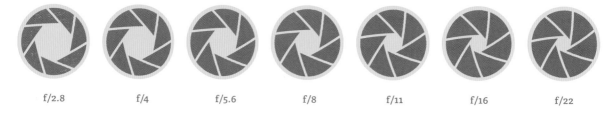

| f/2.8 | f/4 | f/5.6 | f/8 | f/11 | f/16 | f/22 |

▲ The aperture in your lens is measured using f-stops: the bigger the number, the smaller the hole.

## I'm confused: 16 is a bigger number than 4, but an aperture of f/16 is smaller than f/4 – why is this?

Although apertures are pretty unintuitive, the reason here is actually pretty simple: an f-stop is a fraction. So, just as 1/16 would get you a smaller slice of pie than 1/4, an f-stop of f/16 is smaller than f/4.

APERTURE F/1.8

APERTURE F/19

## ◯ How should I decide which f-stop to use?

Choosing the aperture usually depends on one of two things: the light levels and creative choices. If the light levels are low, a wide aperture will let in more light, but if the light is very bright you might need to use a smaller aperture. In this way, your f-stop choice could simply come down to how bright it is. But your aperture setting will also determine the depth of field, which is the zone that appears sharply focused in a photograph. Depth of field can extend right the way through an image, from the closest point in the shot to the furthest (which is great for landscapes where you want to show the entire scene), or it can be reduced so that only your subject is in focus and everything in front of it and behind it is blurred.

This makes choosing your f-stop more of a creative decision, although in reality you will find that every exposure you make is about finding the balance between aperture (depth of field), shutter speed (blur) and ISO (noise) – it's not just the aperture that you need to think about.

◀ Controlling depth of field is a potential reason for choosing one aperture setting over another – do you want everything to be as sharp as possible, or just a small part of the image to appear in focus?

## ◎ How can I get rid of a distracting background in my portrait shots?

Blurring an otherwise distracting background is a great way to make your subject 'pop', and it ultimately comes down to limiting the depth of field. By far the easiest and most effective option is to use a wide aperture, so start by setting the aperture to f/4 or wider. Be warned, though – the wider the aperture is, the less depth of field there is, so the more accurate your focusing needs to be (with portraits, focusing on your subject's eyes is usually best). Depth of field is also affected by the distance between the camera and subject (the closer they are, the less depth of field there will be) and by the focal length, with telephoto focal lengths giving less depth of field than wide angles. However, as longer lenses usually mean you have to shoot from further away, these two things can often cancel each other out when it comes to depth of field, which is why aperture is the go-to control.

▶ Taken at a zoo with a 200mm focal length, I set an aperture of f/2.8 for this wolf portrait. This threw the potentially distracting background – and foreground rock – out of focus, concentrating attention on my majestic subject.

## ◎ How can I make sure everything in my landscape shots is sharp?

While a wide aperture setting reduces the depth of field in an image, a small aperture (such as f/16 or f/22) has the opposite effect and will increase the depth of field so you can get as much as possible in focus. This is great for landscape shots, or any other scene where you want to show everything equally clearly. Setting a small aperture does reduce the amount of light passing through the lens, though, so you will usually need to counter this by using a slower shutter speed or a higher ISO.

▶ With a 50mm focal length I needed an aperture setting of f/16 to keep everything in this shot sharply focused.

# When I use the smallest aperture setting my photos look 'soft' – is there a problem with my lens?

There could be, but a more likely explanation is that you're seeing the effects of diffraction. When light travels through a lens it passes through the aperture. When the aperture is wide open, the light waves can pretty much travel in a straight line, but as the aperture gets smaller, the light 'bends' as it passes through the tighter hole. This can cause the light waves to interfere with each other, making the image softer.

The precise aperture setting at which this becomes noticeable will come down to a combination of the camera and lens you're using, and the size you view your images at, but in every case it can be fixed by using a wider aperture setting.

Diffracted light

Undeviated light

Small gap

Undeviated light

Wide gap

Diffracted light

▶ As light passes through a narrow gap – in this instance, a small aperture in the camera lens – it spreads more, leading to increased diffraction and 'soft' images.

# Shutter speed

Fast or slow? Your choice of shutter speed has a significant part to play in the creative process.

### ✦ I took some shots of fly-pasts at an airshow and they're all blurred – how can I fix this?

The most likely cause is that your shutter speed was too slow. For fast-moving subjects, you need to make sure that you're using the fastest shutter speed you can, so I'd recommend setting your camera to Shutter Priority and dialling in a shutter speed of 1/1000sec. or faster. If you set the ISO to Auto, your camera will take care of both the ISO and aperture, which are both secondary in this scenario – the main thing is that your shutter speed is fast enough to freeze the movement.

▲ Having a little bit of motion blur can sometimes add 'life' to your subject – this helicopter was shot at 1/750sec., which has recorded some movement in the rotor blades.

◀ It is typically brighter outdoors than it is indoors, which means you can more easily set a shutter speed that will minimise the risk of camera shake. This shot was taken at 1/1500sec. with an aperture of f/1.8 and ISO 800.

## Why are the photos I take of my kids indoors blurred, while the shots I take outside are fine?

Blurred shots taken indoors generally come down to low light levels, which in turn lead to a shutter speed that's just too slow to keep everything sharp. If your kids are charging around indoors, motion blur is going to be your biggest challenge, so switch your camera to Shutter Priority mode, set the ISO to ISO 1600–3200, and dial in a shutter speed of at least 1/250 sec. This should be fast enough to 'freeze' your kids – if it isn't, increase the shutter speed (and ISO if necessary).

If your kids are sitting or standing still and your shots are blurred, then camera shake is the most likely cause, but the solution is broadly similar: you need to use a faster shutter speed. The rule of thumb for avoiding camera shake is to use a shutter speed that's no longer than the reciprocal of the focal length. So, if you're using a 50mm focal length you would want to use a shutter speed of at least 1/50 sec. – with a 100mm focal length it would be at least 1/100 sec., and so on. However, things are complicated slightly if you're using a cropped-sensor camera, because you need to base your shutter speed calculation on the effective focal length. Also, if your camera or lens has image stabilization this will let you use slower shutter speeds. If in doubt, a simple solution is to aim for a shutter speed of around 1/200 sec. – that will be fast enough to avoid shake with all but the longest telephoto lenses.

# ISO

The third player in the exposure triangle is ISO, which is often overlooked, but is just as important as aperture and shutter speed.

### ⬤ When I shoot indoors I get a 'gritty' texture in my shots – why is this?

A gritty or grainy texture is usually a sign that a high ISO setting has been used to take a shot. It may be that you set it yourself – dialling in ISO 6400 to shoot in a dimly lit room, for example – or that your camera's set to Auto ISO (or its full Auto shooting mode) and has chosen a high ISO for you. In either case, what's happening is your camera is 'boosting' the signal that's coming from the sensor that's going to form your picture. However, as well as amplifying the signal that will form your photograph, it also amplifies any non-image-forming elements, or 'noise' as it's more commonly known. Consequently, when you crank up the ISO, you also crank up the noise, which appears in your photos as that gritty texture.

▶ I shot this shelf of curios indoors on an overcast day. Its position meant I had to shoot handheld and needed a reasonable depth of field, so I settled on an exposure of 1/80sec. at f/5.6. But, to achieve this, I needed to set the ISO at 6400, which has added noticeable noise. Turn to page 152 to see if it can be removed…

DETAIL AT ISO 6400

### ⬤ Is film ISO the same as the ISO setting on a digital camera?

Yes and no. Superficially, they both represent sensitivity to light, and dialling in ISO 400 on a digital camera has the same effect on your exposures as loading ISO 400 film. However, they work in fundamentally different ways. With film, the ISO (or film speed) is determined by the size of the silver halide crystals within the emulsion, with larger crystals more sensitive to light, so it's a physical property. With a digital sensor, ISO refers to the amplification of the signal generated by the picture-forming light reaching the sensor, with higher ISOs indicating greater amplification. So, strictly speaking, the sensitivity of the sensor doesn't change at all.

## ⚙ Why do some cameras have an ISO Priority mode, but others don't?

Because digital cameras let you change the ISO from shot to shot, some manufacturers have introduced an ISO Priority mode, where you set the ISO and the camera sets the aperture and shutter speed. It's not a feature on many cameras, and it's not really necessary, either. Why? Because Program mode can essentially do the same thing. If you set your camera to P and select an ISO setting, the camera will sort out the aperture and shutter speed for you – just like in ISO Priority mode. Sure, there are some (very) subtle differences in the programming that underpins these modes, but in the real world they are rarely enough to make a difference.

## ⚙ How do I know what ISO to use?

From a purely technical standpoint, the lowest ISO setting on your camera (excluding any 'extended' options) will give you the best results. This is ISO 100 on most cameras, although it can be as low as ISO 50 or as high as ISO 200 on some models. This is your camera's 'native' ISO, which is the setting that delivers the highest dynamic range and lowest levels of noise from the sensor – or, put simply, the best image quality. However, that's not always going to give you the exposure settings you want or need, so the 'best' ISO is the lowest setting that will give you the aperture and shutter speed you need for your shot.

ISO 100

ISO 1600

◀ ▲ Your choice of ISO will generally depend on the light levels. On a bright, sunny day, ISO 100 might be all you need, which was the case for this shot of a fairground ride. But shoot at night or indoors and you may need to crank up the sensitivity – I needed ISO 1600 to shoot this walkway in Venice, Italy.

# Focus

Where and how you focus can make the difference between a stunning shot and a blurred throwaway.

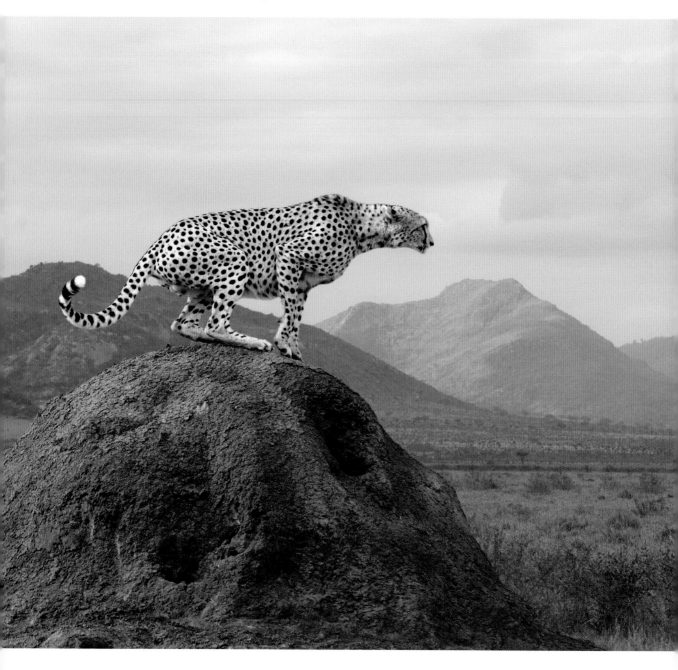

## ⟐ Should I set my autofocus to Single Shot, Continuous or Auto?

Is your subject moving? If you can answer that, then you can set the AF yourself, either to Single Shot for a static subject, or Continuous for moving ones. About the only time you might want to choose Auto AF is if your subject could potentially move. In this situation, your camera will switch automatically from Single Shot to Continuous AF if movement is detected, so you don't miss the shot.

◄ If your subject might start moving, Auto AF can help, as it will switch from Single Shot to Continuous AF when needed.

## ⚙ I want to photograph flowers and insects, but only a tiny part of my shots comes out sharp – what can I do?

The camera-to-subject distance is one of three factors that can affect the depth of field, and the closer you are to your subject, the less depth of field you have. In no situation is this more apparent than in close-up and macro photography, where you might be inches from your subject and the depth of field becomes exceptionally shallow.

Obviously, one option is to set the smallest possible aperture, but even that might not be enough, and it also runs the risk of diffraction softening your shots (see page 65). Instead, if you're photographing a static subject, you might want to consider 'focus stacking'. With your camera on a tripod (this is essential), take a series of photographs, each with a slightly different focus point. The aim is to overlap the depth of field between the shots and shoot a sequence that extends from the nearest to furthest area you want to appear focused in your final image.

You then combine the exposure sequence on your computer using image-editing software or a dedicated focus-stacking program, which combines the sharply focused section from each image to create a single photograph with an extensive depth of field.

▲ With the aperture set at f/16 (to avoid diffraction) it was impossible to get all of these melancholic blooms in focus in one shot. Instead, I took a series of exposures to focus stack using Adobe Photoshop.

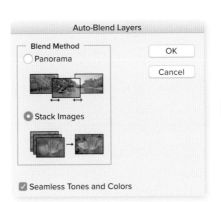

▲ ▼ This involves combing the shots as layers in a single image and then using the Stack Images option in the Auto-Blend Layers tool to automatically mask the sharpest parts of each image

**FOCUS-STACKED IMAGE**

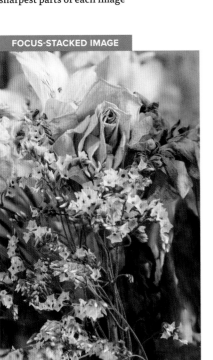

**FINISHED IMAGE**

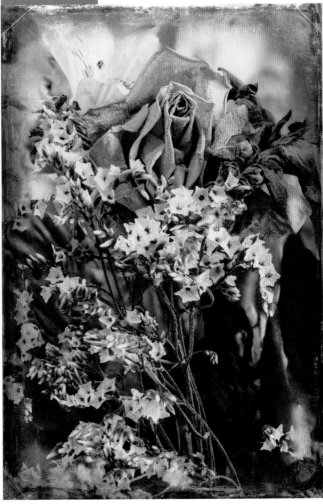

▶ Once this was done I gave the shot a suitable faded look using the Exposure image-editing software.

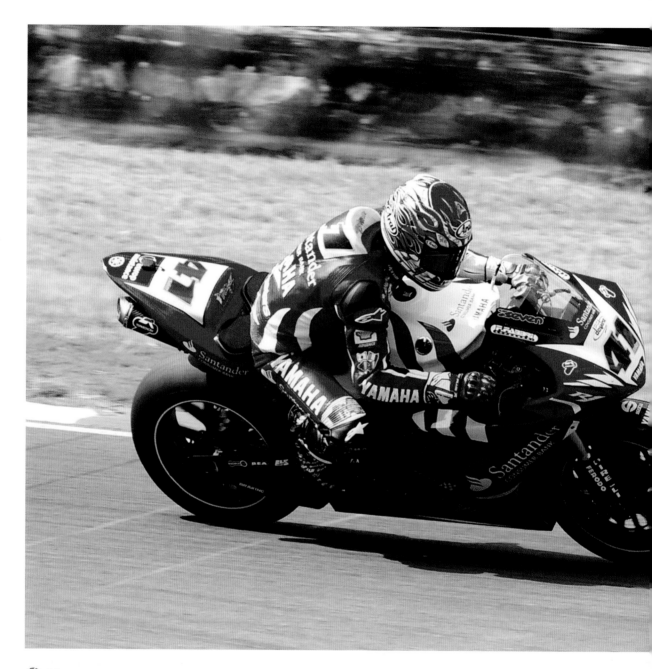

**How can I get sharp shots of motorcycle racing – my camera can't focus fast enough?**

It might sound counterintuitive, but your best bet here is to switch to Manual focus, pick a point on the circuit and focus on that. Then, all you have to do is wait until a bike reaches your 'sharp spot' and rattle off a burst of shots – because your focus is already set, your camera doesn't need to waste any time trying to get a lock on the moving object.

▲ Whether it's motorbikes, race cars or some other fast-moving subject, when it comes to track-based events you will generally know where your potential targets are likely to be. In this instance, I set my exposure, pre-focused manually on a point on the track and waited for the bikes to come around.

## ◉ If image stabilization is meant to make my photos sharper, why does my camera let me switch it off?

Although camera- and lens-based image stabilization can help prevent camera shake, when you handhold your camera, it can potentially introduce a slight blur to your shots if you try and use it when your camera's held steady on a tripod. Similarly, if you are intentionally panning the camera to photograph a moving subject, the stabilization system can get confused trying to cope with the 'extreme' movement and again make things worse, rather than better.

In both cases, switching image stabilization off would be beneficial, although an increasing number of cameras/lenses have specific modes that can be used when the camera is mounted on the tripod, or you are intentionally moving the camera. It's also worth remembering that image stabilization draws power from the battery when it's activated, so if you find yourself in a situation where battery life is critical, turning off your stabilization could be an option if it isn't going to affect image sharpness.

## ⟳ Why does my camera have so many autofocus points?

As a general rule, the more autofocus points a camera has, the more likely it is that one of those points will sit over the area you want to focus on, so having more can definitely be beneficial. However, the number of points is only part of the story. Their 'spread' – how they are distributed across the frame – is also important, because that determines how close to the edges of the frame you can place your focus on (you can have hundreds of AF points, but if they're all concentrated at the centre of the frame that won't help you focus on an off-centre subject). There are also different types of AF points, which determines their accuracy: cross-type AF points are more accurate than linear AF points, while diagonal points are the most accurate of all. How many of these different types a camera has and where they are positioned can make a significant difference to how fast and how accurate the focusing is, so it is the combination of AF point distribution, type and quantity that determines how effective a camera's autofocus system is. But, as for whether you need hundreds of AF points, that's up for debate – after all, it only takes a single AF point to get a sharp shot.

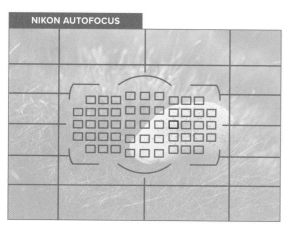

NIKON AUTOFOCUS

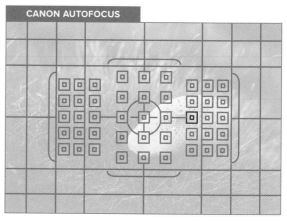

CANON AUTOFOCUS

### How can I stop my focus point changing when I move my camera?

If you're using Single Shot AF then pressing the shutter-release button halfway will set the focus, and if you keep the button held halfway down you'll be able to reframe your shot. Alternatively, you can press and hold your camera's focus-lock (AF-L) button, which will let you do the same thing. This is arguably a better habit to get into as the AF-L button also locks focus in Continuous and Auto AF modes, so it works in any focus mode. However, it's worth remembering that the default setting for both the shutter-release and AF-L buttons will usually lock the exposure as well as the focus. If you only want to lock the focus, you will need to venture into your camera's menu where you can usually specify whether you want these buttons to lock the focus, the exposure or both. Having one assigned to locking the exposure and another to locking focus is a useful option.

◀ ▲ Having AF points towards the edges of the frame can help you focus on off-centre subjects without having to move your camera, but not all cameras have an equal number – or spread – of AF points.

▲ AF-L stands for 'autofocus lock', but the button usually doubles up as an exposure lock (AE-L) as well. Your camera's custom functions should let you separate the two.

# Colour

Getting the colours right in your digital photographs starts with choosing the right colour space.

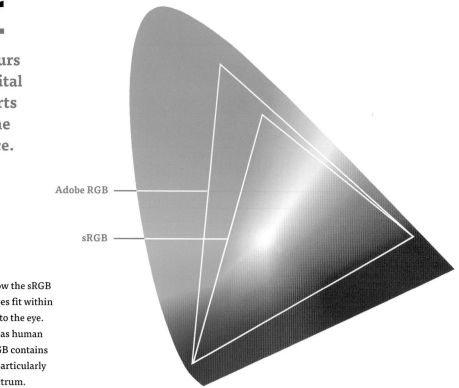

Adobe RGB

sRGB

▶ This illustration shows how the sRGB and Adobe RGB colour spaces fit within the range of colours visible to the eye. Neither one is as expansive as human vision can be, but Adobe RGB contains a greater range of colours, particularly in the green part of the spectrum.

## What's the difference between sRGB and Adobe RGB?

Most digital cameras have two 'colour space' settings – sRGB and Adobe RGB – which are essentially two different 'ranges' of colours. Of the two, sRGB is the smallest, which means it can accommodate fewer colours than Adobe RGB. However, it is the standard colour space used by computer monitors and websites, so if you're only going to be showing your images on screen (and don't want to edit them after they've been shot), shooting in sRGB is ideal.

For anything else I would suggest choosing Adobe RGB, simply because it has a larger 'gamut'. This means Adobe RGB can record more colours than sRGB, especially when it comes to subtly different shades of green (landscape photographers take note). Not only does this mean that you are potentially recording a 'fuller' image in terms of colour, but it also comes in handy when you edit your shots because there's a little bit more leeway as you work. If you later decide that you would prefer a 'simpler' sRGB image, you can easily change the colour space and reduce the number of colours (you cannot, however, expand an sRGB colour space into an AdobeRGB one). It is worth noting that the colour space is only pre-set with JPEG images: if you shoot Raw, you can decide which one you use when you process and export your images (see page 151 for more information).

## Why isn't the sky blue?

The number one culprit for wayward colours in a digital photograph is the white balance, so check that you haven't accidentally switched to a setting that is obviously wrong – fluorescent lighting when you're shooting outdoors, for example. If your white balance is set to automatic (AWB), it could be that the scene itself has confused your camera. This can happen when there's a lot of the same colour in the frame, such as a blue sky above a blue sea, as the camera can mistakenly assume it's a colour cast and try to correct it.

This also often happens when you shoot sunsets due to the warm-coloured light. In these situations, switching from Auto to the most appropriate white balance preset (Daylight, Shade, Cloud and so on) should help, while shooting Raw files will let you make further colour adjustments when you process your shots.

▲ Shot with my camera's white balance set to Auto, this photo came out a little bit too warm. As I usually shoot Raw, it was easy to fix this slight colour cast when I processed the image.

▲ For this 'found' still life I shot in Raw (which is always in colour to start with), and converted the shot to monochrome when I processed the file. This gave me far more control over the final result than my camera would allow.

## I love black and white photography, but how do I make the most of my camera's black and white mode?

The simple answer: don't. Instead, shoot in colour – ideally Raw – and then convert your shots to black and white on your computer. If you work this way you will have far more control over the appearance of your black and white images, including the option to adjust the different tones, which is essential if you want to get the best results (see page 160 for more information).

# Flash

Flash is not only a great way of adding light when it's dark, but it can also be used creatively to add 'zing' to your shots.

### ⟡ My flash photos are ugly – help!

One of the most common causes of unattractive flash shots is direct, on-camera flash, whether that's the flash built into a phone, compact camera or DSLR/mirrorless camera, or a hotshoe flash aimed straight at your subject. In each case, the flash will give you hard frontal lighting, which 'flattens' your subject and typically creates a harsh shadow behind them. The way to avoid this depends on the camera you're using. With a phone or a compact, there's not much you can do about the direction of the light, as the flash is fixed in position, but you can try and soften its output by taping some semi-opaque parchment/ baking paper, tracing paper or similar over the flash. The same technique can be used with the built-in flash on a DSLR or mirrorless camera, although you will also find an array of DIY and off-the-shelf diffusers that you can make or buy.

With a hotshoe flash there are far more options, including bouncing the light off a wall or ceiling (see page 83), reflecting it off a 'bounce board' or using a small softbox or semi-opaque plastic cover that sits over the flash head and diffuses the light. Many of the commercial options have DIY equivalents, so there's no need to spend a fortune here. You might also think about using your flash off camera.

▲ Direct flash typically gives you 'flat' lighting and a bright subject against a dark background. In some instances that's all you want or need, but flash has far more to offer.

### ⟡ Can I use more than one flash off camera?

Absolutely. Most modern TTL systems let you set up multiple off-camera flashes, enabling quite complex lighting setups to be employed where exposure can be set with near point-and-shoot simplicity. Alternatively, you can go old school and use a flash meter to guide you.

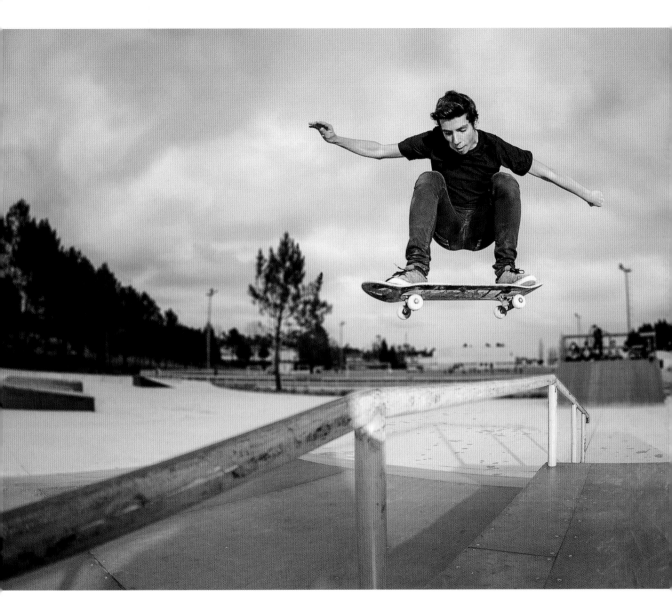

## ◎ **Is it possible to use really fast shutter speeds with flash?**

Yes, providing your flash unit has got a 'high speed sync' (HSS) mode. In this mode, the flash will put out multiple bursts of light as the sensor is being exposed by the slit created by the shutter curtains (see opposite) to create a uniform exposure. The downside is that these pulses are far less powerful than a single flash can be, so you may need to use a wider aperture or a higher ISO, or move the flash closer to your subject.

▲ Shooting with a wide aperture outdoors will give you a fast shutter speed, but a burst of high-speed flash can really help lift your subject from their background.

## ✸ I photographed my kids on the beach, but their faces are in shadow – how can I improve things?

Sunny days on the beach are great for ice cream and splashing in the surf, but they're not so great for photography. Whether your subject is backlit, their face is shaded by a hat or it's simply that the sun is casting strong shadows, it can be difficult to get a good shot relying on just the daylight around you.

One option is to use a reflector to bounce light back onto your subject and 'fill in' the shadows, but as very few of us take a reflector to the beach, an easier solution is to use your camera's built-in flash. It's not going to be powerful enough to be the dominant light source, but quite often it's perfect for adding a subtle shadow-lifting light. Keep an eye on the shutter speed if you're using a DSLR or mirrorless camera in Manual or one of the Priority modes, as sunny days can easily give you a shutter speed that's just a little bit too fast to sync with your flash (see page 81). Choosing the lowest possible ISO and a smaller aperture is usually enough to avoid this.

▲ Whether it's hard lighting from the sun or a hat shading the face, countless holiday photos have been ruined by hard shadows. The simple solution is to fire your camera's built-in flash to help smooth things out – in this shot, I used a combination of flash with cross-processing to help the colour 'pop'.

## ✸ What's the difference between TTL and Auto flash?

It's all about control. Auto flash was developed when manual film cameras just didn't have the 'brains' to deal with a flash exposure. Instead, the flash unit took control of the exposure, using a built-in sensor to read the light reflected off the subject and control the flash. This worked completely independently of the camera, but as long as you told the flash what aperture you were using and made sure you were the right distance from the subject, it would do a pretty good job of giving you the right amount of light. However, as cameras got smarter, they could start calling the shots, and with TTL (Through the Lens) flash control it's the camera that's in charge. Information such as the focal length of the lens, the distance it's focused at, the aperture and shutter speed settings you've got dialled in and more can all be used to determine the optimum exposure, and a 'pre-flash' can be used to make sure it's right.

▲ Compared to the digital displays on most TTL flashes, the colour-coding system used by auto flashes looks decidedly low tech, yet it can be surprisingly accurate.

BOUNCE FLASH

DIRECT FLASH

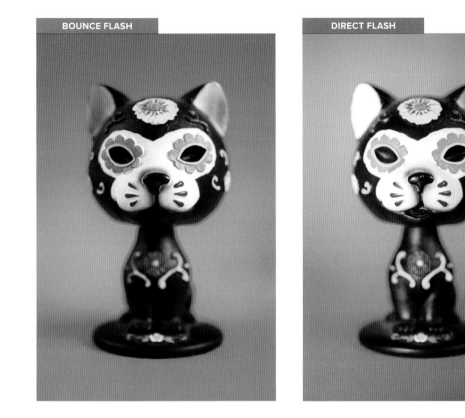

## ⚙ How do I 'bounce' my flash?

The mechanics of bouncing the light from a flash are pretty simple: you just need to tilt or turn your hotshoe flash so the light reflects off the ceiling or a wall onto your subject. In doing so, the light will not only be much softer, as it spreads more, but it will also be less directional. When it comes to determining the exposure, the easiest option (and the one most people would go for) is to use TTL flash control and let the camera work things out for you.

If your shots are a bit dark, it's most likely because your flash isn't quite powerful enough to match your exposure, so bump up the ISO by a stop or two and/or open up the aperture to see if this improves things. If not, consider moving closer to your subject as well.

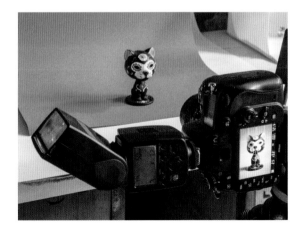

▲ The difference between direct flash and bounce flash is obvious here: bouncing the light has 'softened' the lighting and removed the distracting shadows from the background. Using a TTL flash, all I had to do to achieve this was tilt the unit so it was aimed at a white wall to the left of the camera.

## ◉ I want to set up a small home studio for shooting portraits, but what lighting kit should I choose?

It used to be that any 'serious' home portrait studio would be based around two or three small studio strobes, mainly because this type of flash could be affixed with a wide range of light-shaping accessories, such as reflector dishes, softboxes and snoots. That's still an option, but it isn't the only one any more. For a start, many of today's sophisticated hotshoe flashes allow you to attach studio-style accessories, so you can not only use a softbox or snoot to modify the light, but also benefit from TTL flash metering and the convenience and flexibility of battery-powered lighting – shooting studio-style portraits outdoors is now a very real option. The downside is that this sophistication comes at a cost, and even third-party hotshoe flashes tend to be more expensive than their studio-based relatives. As an alternative to flash, there's also a plethora of continuous light sources, ranging from LEDs to fluorescent lights. In-camera white balance makes colour casts a thing of the past, and either type of light can deliver professional results with the convenience of a 'what you see is what you get' approach.

However, continuous lighting does have its limitations. It tends not to be as bright as flash, so it's often harder to freeze movement or use small aperture settings without turning up the ISO, and you can also be quite limited in terms of the accessories that are available; for a lot of portrait work, being able to control and direct the light is essential. That said, continuous lighting – particularly fluorescent lamps – can be far cheaper than flash units, which is worth bearing in mind if you can live with their limitations.

▶ Although flash is the traditional lighting option for portrait photographers, LED lighting is becoming more widely available. Many manufacturers, such as Interfit, offer both options and design them so they can be used with the same lighting accessories.

## ◉ Why am I only getting half a picture when I use my flash?

Check the shutter speed you're using. DSLRs have a mechanical shutter that utilizes two 'curtains' (also referred to as 'blinds' or 'blades') to make an exposure. When you take a shot, the first curtain opens to start the exposure and the second one closes to end it. At shutter speeds up to around 1/200sec., the first curtain is fully open before the second one starts to close, so the sensor is exposed

in its entirety to light. However, at faster shutter speeds the second blind starts to close before the first one has fully opened, which means the sensor is effectively being exposed to a fast-moving 'slit' of light. Consequently, when you use a fast shutter speed with flash, the brief burst of light only exposes the part of the sensor that is revealed by the slit at the time, and the rest of the sensor is unexposed, leading

to a partial image. To avoid this you need to use a shutter speed that is equal to, or slower than, the camera's 'flash sync speed', which is the fastest shutter speed at which the entire sensor is exposed to light. The exact shutter speed varies between camera models, but it is typically in the region of 1/200sec. – if you're unable to find it for some reason, setting the shutter speed to 1/60sec. is guaranteed to work.

## ✺ Should I bother with manual flash?

A lot of studio strobes (see opposite) are essentially manual flash units, and working with these is definitely worth considering if you're into studio photography. You might also want to consider setting a TTL flash to Manual when you want to control the duration of the flash. Although a burst of flash is brief, it still has a start and an end, and there's a tiny fraction of a second between the two.

This flash duration is linked to the flash power, and the lower the power setting, the shorter the burst of light lasts. In some instances, being able to manually reduce the flash power to create an ultra-brief flash duration can be an incredibly useful way of freezing ultra-fast movement – the split-second of a 'crowning' water droplet, for example.

You will need to be shooting in low-light conditions for this to work, so that the flash is the sole light source and the ambient light doesn't affect your exposure. This way, the flash duration effectively becomes your exposure time – your camera's shutter speed might be set to a sync speed of 1/200sec., but the flash duration (which is what is actually creating the exposure) could be 1/2000sec. or faster.

▲ Being able to control the power – and therefore duration – of a flash is useful if you want to freeze exceptionally brief moments in time, although for droplet shots like this you will need some fairly specialist triggers as well.

▲ I shot this for a lampshade-maker using studio strobes and you can clearly see what happens when you use a shutter speed that exceeds the camera's sync speed. At 1/125sec. the image is exposed entirely, but at 1/250sec. – just a tiny bit faster than my camera's 1/200sec. sync speed – there's a dark band at the right of the frame. At 1/500sec. less than half the frame has been exposed.

# IN THE FRAME

What you include in your shots and where you position it in the frame will have a fundamental impact on your photographs, so it pays to learn the rules and know when and how to break them.

## ⟳ What are the biggest mistakes I can make with my photographs?

From exposure to focus, to colour, to framing your shots, there are plenty of areas where things can go wrong in photography, but really there is only one 'mistake' you can make. And that is not getting the shot you want. I've taken shots that are deliberately out of focus, underexposed or overexposed, that have the subject cut off at the edge of the frame, that have the wrong white balance, and more. Each one of these could fall into the category of 'mistakes', but if you deliberately underexpose a shot for dramatic effect, or purposely set the wrong white balance, it is simply part of the creative photographic process – it is only a mistake if it's not what you intended.

▲ The obvious mistake with this shot is that it's out of focus. However, I deliberately defocused the lens because I wanted a soft image that blended the sunset colours a little more, so it's not really a 'mistake' at all!

## ⟳ How can I make my landscapes more dramatic?

One of the easiest ways of adding drama to a landscape shot is to carefully choose the time of day when you shoot. Sunrises and sunsets usually deliver far more interesting shots than those taken in the middle of the day, as the low, raking light highlights textures and can be accompanied by great colours in the sky. The so-called 'golden hour' (the period just after sunrise and just before sunset) is an incredibly popular time for landscape shooters for this reason, but if you head out earlier and shoot pre-sunrise, or stay later to shoot post-sunset, you can also take advantage of the 'blue hour', when there's light in the sky but the sun is below the horizon. While sunrises and sunsets have drama, the blue hour often imbues scenes with a cool blue colour palette.

Beyond that, you need to start thinking about how you arrange the elements in the frame. Leading lines such as walls, rivers and roads that extend into the shot are a great way of drawing the viewer's eye into and around an image, while including something close to the camera ('foreground interest') can create a sense of depth, while also linking the nearest and furthest elements. Shooting from a low angle with a wide-angle lens can have plenty of impact here.

▶ Shooting at sunset towards the light added drama by introducing complementary colours (see page 92), while the converging lines of the old jetty create strong leading lines that draw you into the frame. The offset marker pole at the end of the jetty breaks the symmetry.

## ⟳ Where should my subject be?

There's a whole host of 'rules' about where you can place the subject or focal point of your shot in the frame, including such prescriptive methods as the golden ratio, golden triangle and the rule of odds. But by far the most enduring for photographers is the rule of thirds, which involves imagining your frame is divided into three equal 'slices', both horizontally and vertically (as illustrated below).

The lines of the grid that divides your frame serve as guides to placing your subject, as it gets them away from the centre of the frame — the place where the casual shooter or budding amateur might typically place their subject. Moving your subject to one side or the other, or up or down in the frame, instantly elevates your photography to the next level, so instead of having the horizon running through the middle of the frame in a landscape, you might have it running across the lower thirds line to emphasize the sky, or across the upper line to accentuate the ground. The points at which the thirds lines intersect are also powerful spots for placing key elements, such as an eye in a portrait or a distant landscape feature.

◄ ▶ Both of these landscapes utilize the rule of thirds. With the first, I placed the tree at the upper-right intersection of the thirds lines, with the stream acting as a 'leading line' up to my subject.

▶ For the second, I used the horizontal thirds lines to locate the horizon and the line of backlit plants in the foreground, and the right vertical thirds line for the distant farm house.

## ✺ Where can I find inspiration?

Type this question into your search engine and the internet will spit out lists of 'ways to get inspired', ranging from a walk in nature to visiting an art gallery, but there's really no definitive source of inspiration that we can tap into. However, perhaps one of the best (and worst) sources of inspiration that we can all draw on is other people's photography. Whether it's Instagram or Flickr, we're all drawn to what we like in a photographic sense, and immersing ourselves in this sea of imagery is a surefire way of encountering pictures that make us want to pick up our camera and shoot for ourselves.

The danger, though, is that we're being inspired to copy, rather than create, so the challenge is not to replicate the shots you see, but to try and put your own spin on them. A simple way of doing this is to take maybe two or three different images that inspire you and see if you can combine them in some way. Maybe take the lighting from one shot that you like the look of, the subject from another and the processing from a third, creating your own unique – and hopefully inspiring – photographs along the way.

▲ Although the internet can provide you with endless inspiration, I still love to turn the pages in a book. This is a tiny selection of the artists who inspire me for one reason or another, including filmmakers, comic book artists and – of course – photographers.

## ✺ Do my photos have to be rectangular?

Convention suggests that photographs should always be a variation on the square or rectangle, and that's certainly the shape that you'll see most often. But travel back towards the dawn of photography and things were far less square-shaped. The first Kodak Brownie cameras produced circular images, for example, and you could argue that this is the 'natural' shape of photographs, as lenses project a circular image with the film or sensor taking a rectangular cut from its centre. So don't feel you are confined by those four walls – break free and try something different!

▲ I spotted this cheeky piece of graffiti on a wall in Paris and decided to crop it to a circle to get rid of the 'dead' corners (it was just more wall) and echo the curves in the stencilled paintwork.

◀ ▲ Complementary colours sit directly opposite each other on a colour wheel and one will make the other 'pop', creating more dramatic and energetic images. Using colours that sit next to each other creates a harmonious palette and a calmer photograph.

## ⟲ What's a 'complementary' colour?

Photographers talk about complementary colours a lot, and with good reason, as they're a great way of adding impact to a colour photograph. Essentially, complementary colours sit opposite each other on the colour wheel (see illustration) and when you put them together they each help the other to 'pop'. Green and red is a classic complementary colour combo, and is regularly found in nature with red berries, flowers and toadstools sitting among the green of leaves and grass. Blue and orange are also frequently encountered at the ends of the day, when warm orange sunsets and artificial lights are complemented by blue skies. Yellow and purple is less common in the natural world, but can be called upon in studio settings; think clothing in fashion shoots and accessories in still life setups, for example.

Complementary colours also have an opposite: harmonious colours. These are colours that sit next to each other on the colour wheel, and rather than creating images that shout out for attention, harmonious schemes have a more relaxed feel (especially when the colour palette relies on greens and/or blues). Again, you can encounter harmonious colour schemes in the natural world (the cool tones of landscapes shot during the blue hour, for example), or you can apply the theory to shots where you play a more directorial role. In either case, complementary and harmonious colours are a good way of controlling the mood and intensity of your photographs, and are a great entry point into the absorbing world of colour theory.

## Does my focal length change the perspective in a shot?

This is a common myth, but the fact is, no matter what you read – or who wrote it – focal length categorically does not change perspective. A really simple way to put this to the test is to take two photographs of the same subject, from the same spot, one using a wide-angle focal length, the other with a telephoto lens. If you crop the wide-angle image to match the framing of the telephoto shot you will see that the perspective in the crop and the telephoto shot are the same. All that's happened is that the wide-angle focal length has recorded a wider angle of view.

The confusion arises because the two uncropped shots look so different – the elements in a telephoto shot appear 'compressed', while a wide-angle focal length appears to 'extend' the distance between them. This is purely down to the camera-to-subject distance and the lens' angle of view – as the simple test just described will reveal, if you crop a wide-angle view you will end up with the same 'compressed' look that a telephoto lens gives.

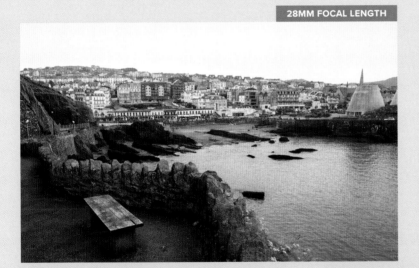

28MM FOCAL LENGTH

◀ ▼ Shot at focal lengths of roughly 28mm (wide-angle) and 160mm (telephoto), these photos appear to show a very different perspective to one another – the wide-angle shot seems to exaggerate the distance between near and far, while the telephoto shot appears to have compressed the distance. However, if you crop the wide-angle shot you end up with a very similar result to the telephoto image, proving that the focal length hasn't changed the perspective – it is the same in both images.

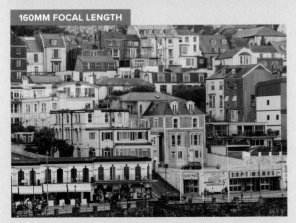

160MM FOCAL LENGTH

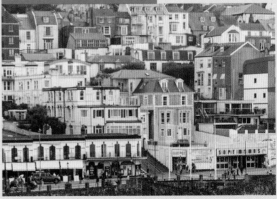

CROP OF 28MM FOCAL LENGTH

# How can I shoot a calming seascape?

Super-slow shutter speeds are the way to go here, so set your camera up on a tripod, add a strong neutral density filter and let your exposures last for several seconds, or perhaps even minutes. In doing so, even the wildest waves will take on a mist-like appearance, echoed by any clouds as they trace across the sky. Alternatively, you could consider using intentional camera movement (ICM: see page 98) to introduce some deliberate blur – panning along the horizon, for example, can reduce the sea and sky to two simple blocks of colour. For added calm, shoot just before sunrise or after sunset, during the blue hour, when everything takes on a soft cool hue, or convert your shots to black and white.

▲ This ultra-minimal seascape consists of just two elements: sky and sea in equal measure. I deliberately defocused the lens to remove any detail, set an Incandescent white balance (in daylight) for a heavy blue colour cast and cropped it square to emphasize the symmetry. The result? A simple, calming seascape.

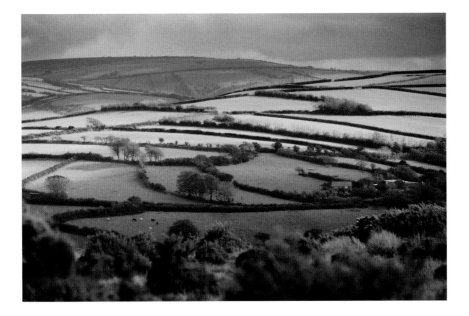

## How can I create a sense of depth in my photographs?

When we look with our eyes, we never see everything with equal sharpness – the point we're looking at is in focus, but anything closer or more distant is blurred to a certain extent. We naturally associate this 'blur-sharp-blur' vision with distance, and we can use the same effect in our photographs to suggest depth. Using a wide aperture setting to limit the depth of field (the sharp zone in our shots) is a great start, but you can also 'shoot through' something in the foreground. Having something close to you that is heavily defocused emphasizes the idea of distance and immediately increases the sense of depth.

▲ With this shot, I decided to include the bushes close to me at the bottom of the frame. Shooting at f/5.6 threw them out of focus, and this blur is just enough to create a strong sense of depth in the image.

## Which five landscape photographers will inspire me?

- **Ansel Adams:** arguably the 'granddaddy' of landscape photographers, and a go-to guy for anyone interested in stunning black and white work.
- **Valda Bailey:** uses ICM and multiple exposures to produce expressive, abstract images that are often about the feel of the landscape, rather than its appearance.
- **Michael Kenna:** a master of ultra-long exposures and minimal black and whites.
- **Trey Ratcliff:** considered a pioneer of HDR imaging, so eye-popping colour is often the order of the day.
- **Isabella Tabacchi:** an artist who shows just what can be done during post-processing to transform a digital image into a drama-soaked photograph.

## Should I crop my shots?

There is a school of thought (largely credited to the street photographer Henri Cartier-Bresson) that believes that a photograph should be shown uncropped, as that demonstrates the true skill of the photographer creating the image. However, while seeing and framing your shot precisely is a valid goal, you shouldn't think that cropping makes you any less of a photographer. For a start, not everything you photograph will fit neatly within the rectangular frame of your camera. Some images will look better in a square format, for example, while others will look better as an elongated panorama. In this case, cropping is essential if you want to create the strongest image, and I'd argue that knowing when and how to crop an image is a fundamental skill to learn.

Cropping can also be useful when it comes to 'tightening' a shot. Sometimes you might not be able to get close enough to your subject to get the shot you want, either because you can't physically move closer or because your lens just isn't long enough. This isn't your fault, but it can easily lead to a 'loose' composition that cropping can quickly remedy. As I've said before, these are your photos so do whatever you think is needed to make them as strong as they can be.

▶ I took this shot in my camera's 'native' 3:2 aspect ratio, but it lends itself to a variety of alternative crops. The 1:1 (square), 5:4 and 16:9 (widescreen) crops shown here are all traditional 'photographic' formats – personally I prefer the slightly panoramic 16:9 frame over the rest, but there isn't really a 'right' answer.

1:1 CROP

5:4 CROP

3:2 CROP

16:9 CROP

**MANIPULATED IMAGE**

**ORIGINAL IMAGE**

◀ ▲ The source for this abstract image was a shot of light-coloured grasses against deep blue water, which I converted to a hard black and white shot (above). I then copied the image three times and flipped and rotated the copies to create multiple 'reflections' in a single shot. Although it now doesn't really look like 'anything', it is still based on 'something'.

## Do my photographs always have to be of a person or a place?

Your camera always needs to be pointed at 'something' to make a photograph, but that something doesn't have to be recognizable. There are plenty of photographers who shoot in a more abstract style that (often literally) blurs the boundaries of what the subject is, be it through the use of ICM (see page 98), multiple exposures or simply by defocusing the lens to introduce a little bit of ambiguity. You can also photograph naturally abstract elements such as peeling paint or rust – plenty of textures can become abstract when they're explored with a macro lens. The trick is not to think too much about 'what' you're photographing and more about the shapes, colours and textures that it's created from.

## ⟨⟩ What does 'ICM' mean?

ICM refers to the technique of 'Intentional Camera Movement', which has seen a huge surge in popularity in recent years. Although there are numerous approaches, they all boil down to one thing: deliberately moving the camera during an exposure. This could mean panning vertically or horizontally while you shoot a static subject, such as panning vertically to blur and elongate trees, or it could be a more random movement that reduces your subject to an abstract series of blurs and smears. You might even want to try throwing your camera in the air to experiment with the random images that are created by 'camera tossing'. In each case, a low ISO and relatively slow shutter speed is the usual starting point, with your movement of choice being made while the shutter's open.

▼ With the shutter speed set at 1/6sec. I photographed red berries on a tree against a strong blue sky, intentionally moving the camera during the exposure. I cropped it square and gave the Vibrance a boost in Adobe Photoshop to finish off this energetic colour abstract.

## ✺ Are there any quick and easy ways of improving my portrait shots?

Filling the frame with your subject, getting direct eye contact and focusing on the eyes will get you off to a good start. You can take things further by using a wide aperture to throw the background (and foreground) out of focus, and perhaps use a weak burst of fill-flash to lift your subject slightly and add sparkling catchlights to their eyes.

◀ I took this shot of a mechanic inside his workshop on black and white film. An open door gave me dramatic side lighting and a catchlight in his eye, while a wide aperture threw any background distractions out of focus. I also went with tight, off-centre framing rather than a more predictable 'full face'.

## ✺ Which five wildlife photographers will inspire me?

- **David Doubilet:** an underwater specialist and pioneer of 'split field' imaging, which combines both underwater and above-water views in a single shot.
- **Tim Laman:** ornithologist and photographer; the first person to photograph all 39 bird-of-paradise species in their native habitat.

- **Frans Lanting:** recipient of the 2018 Wildlife Photographer of the Year Lifetime Achievement award.
- **Cristina Mittermeier:** National Geographic photographer and founder of the International League of Conservation Photographers (ILCP).

- **Joel Sartore:** founder of the National Geographic Photo Ark project, which aims to photograph approximately 15,000 species living in zoos and wildlife sanctuaries around the world.

## How can I add drama to my cityscapes?

There are countless ways you can add drama to photographs of action-packed city streets, ranging from shooting at dusk and dawn, when the colours of artificial lights contrast with a rich blue sky, to shooting in the rain, as umbrellas come out and people dash for cover (slow shutter speeds are worth experimenting with here). Meanwhile, the hard shadows cast by buildings and doorways on sunny days can add a graphic edge to your shots — especially in black and white — so this is the perfect time to look for areas of high contrast and shadowy mystery.

You can also think about your shooting position. Most of us are familiar with how the world looks from eye level, but a bird's eye view or a worm's eye view is less ordinary and therefore more exciting. Finding a tall building that you can use as an elevated shooting platform will provide you with an aerial view of the streets below, or you can get your camera down to ground level and look up at the world. A rear LCD screen that can be angled upwards can help you frame your shots in this situation, or you can simply 'shoot blind' and crop your images later.

▲ As well as choosing the time, weather and shooting angle, look for reflections in glass and metal that can add a slightly abstract look to your cityscapes.

▲ Using a slow shutter speed will introduce blur into your shots, which suggests movement, speed and energy. Converting to black and white gives this shot a classic street photography vibe.

## ◌ How can I add some 'energy' to a street shot?

For me, this has got to be about movement. When I think about streets, and cities in particular, it's the hustle and bustle of life that comes to mind; it's the traffic, the people and the seemingly urgent and accelerated pace of human existence. To convey this photographically, slow your shutter speed and let life move while you shoot. Shooting at around 1/15–1/30sec. with an image-stabilized camera or lens will typically let you get a sharp shot handheld with a focal length of up to 100mm, and this is often enough to introduce a bit of motion blur as people scurry past their sharply focused surroundings.

## Which five fashion photographers will inspire me?

- **Miles Aldridge:** an artist with a hyper-real cinematic style, often underpinned by intense colour.
- **Nick Knight:** widely regarded as one of the world's best.
- **Sarah Moon:** model turned photographer with a painterly approach to photography.
- **Juergen Teller:** known for his use of the 'snapshot' aesthetic, often shot on film with direct flash.
- **Ellen von Unwerth:** playful, provocative and vibrant.

▲ Having recently moved to the coast, gulls are all around me and are the ideal subjects for a long-term project. This image combined two shots taken as part of a rapid 'burst' of frames, which I converted into three 'panels'.

## ◎ I want to start a project – any ideas?

Photography projects can come in many guises. Perhaps there's a hobby or sports activity that you do that you could document with your camera? Or maybe you could take some shots where you work? Alternatively, you could base your project on a particular location, photographing people and their dogs in your local park, for example, your neighbourhood's shop owners, or perhaps just the people who live on your street. If confronting strangers isn't your thing, how about self-portraits instead? Plenty of people set out on 365-day self-portrait projects at the start of the year, but can you see it through to the end?

Once you've got a subject sorted, start to think about the look of your project. Maybe you want to tell a story with shots that look like stills from a movie, with a mix of long, establishing shots setting a scene, mid-range shots revealing a little more and detailed close-ups? This can work well for fluid, documentary-style projects where you shoot the action as it unfolds. Or perhaps you want to adopt a deliberately consistent aesthetic, posing your subjects in a similar way and using the same lens, shooting angle and processing to create a series of 'same-but-different' images – this could work well for those neighbourhood shop owners, for example. In either case, decide if you want to shoot in colour or black and white – most projects work well if you use one or the other, rather than a mix of both, but this is your project, so change things up if you want to.

# ⟳ How do I copyright my pictures?

In most countries, copyright is assigned automatically to the person who takes a photograph. This means that as soon as the shutter closes, you own the copyright to the image you have just created and no one else on the planet can use it or share it without your permission. There are exceptions, though. If you're undertaking a paid commercial shoot, for example, it's likely there will be a clause in your contract that gives the client copyright of the images (which makes sense seeing as they're paying for them), and if your employer asks you to take some shots as part of your job, they might expect copyright of those as well. However, your client or employer can't just assume they own the copyright because they've paid you – the general rule is that you need to sign copyright over to the other party, so there's got to be something in writing. This can vary from country to country, though, so it's worth checking the relevant rules and regulations to be sure.

It's also worth noting that while copyright is usually assigned automatically and for free, many countries also have voluntary copyright registration schemes. There will be a fee involved for these, but they help create a formal, dated proof of ownership for your work that adds an extra layer of protection.

◀ ▲ Some cameras can be set up to add copyright details to your images when you shoot, or you can enter it into the shot's 'metadata' when you process your images. Neither option will prevent your images from being used without your permission, but it does at least send a clear message that you own the copyright of the shot.

# ⟳ Which five portrait photographers will inspire me?

- **Nadav Kander:** often dark, sometimes blurred and with a distinctive colour palette, Kander has photographed everyone from street children to the British Royal Family.

- **Dorothea Lange:** most closely associated with black and white documentary portraits taken during the Great Depression of the 1930s.
- **Annie Leibovitz:** best known for her celebrity portraits of Hollywood superstars, musicians and politicians.

- **Platon:** has photographed numerous world leaders and celebrities, with a distinctive 'face-on' style.
- **Cindy Sherman:** the original 'selfie' artist, who often used herself as her subject.

## ⚙ Do I have to stick to the compositional rules of photography all the time?

If there's one rule to rule all the rules, it's that they're not really 'rules' at all. Some photographers behave as if these so-called rules form some sort of photographic law, but the simple fact is you don't have to follow them if you don't want to. Yes, placing your subject off-centre can be more visually interesting than having it in the middle of the frame, but sometimes it can pay to place your subject slap-bang in that central spot or so far to one side that it's cut off by the edge of the frame. These are your photographs, after all.

▲ This shot doesn't particularly stick to any rules – the birds are cut off by the edge of the frame for a start. But it's a far more interesting shot than the 'regular' photos I took of the same gulls that show them in full.

## ⚙ Which five street photographers will inspire me?

- **Henri Cartier-Bresson:** the man behind 'the decisive moment', known for his candid street shots.
- **Bruce Gilden:** an artist with a confrontational street shooting style that combines an 'in-your-face' camera with flash.

- **Vivian Maier:** unknown until after her death in 2009, when her archive of more than 150,000 images came to light.
- **Joel Meyerowitz:** an early and enduring champion of colour street photography.

- **Garry Winogrand:** best known for his classic black and white shots of New York City in the 1960s and '70s.

# ⊙ I'm in a rut – what can I do?

It's easy to find yourself photographing the same things over and over again and adopting an almost 'fixed' way of shooting. In some instances that's not a bad thing, and this type of predictability and consistency is exactly what forms the basis of some professionals' careers. But if it starts to feel like you're just going through the motions when you shoot, then it's probably time to think about mixing things up a bit. There are myriad ways you can do this – here are just a few options that you could explore to pull yourself out of your creative rut:

- **Try a new genre:** If you normally shoot portraits, go out and shoot some landscapes instead. A (sometimes literal) change of photographic scenery will demand you change your approach, whether it's through your choice of focal length, exposure settings or when you take pictures.

- **Start a project:** Thinking in terms of a series of connected images rather than single shots can encourage you to look more at how you tell a story through photographs, as well as motivating you to keep shooting.

- **Limit yourself:** It sounds counterintuitive, but there's something liberating about limiting yourself to a single focal length and shooting with nothing but that for a week or two. My favourite option here is to stick an old-school manual-focus 50mm prime lens on my camera – without the luxury of a zoom you have to work a lot harder to find your images, but this extra effort is often evident in the resulting shots.

- **Look for colour:** Pick a colour – any colour – and photograph it where you find it. As you aren't limiting yourself to any one subject, your approach will be necessarily broad, which should encourage you to explore a wide range of techniques.

▲ I can't deny it, photographing people isn't really my thing. But when it comes to getting out of a photographic rut, trying something that isn't your preferred subject can encourage you to try new ideas, whether you experiment with exposure settings, focus or, in this instance, the processing.

These are just a few options to get you started, but they all have one thing in common: they can feed back into your more familiar subject choice, rejuvenating your photography in the process. They could possibly even take you in a whole new photographic direction.

# IN THE FIELD

Every photographic subject presents unique challenges, but the solution typically means addressing and balancing two key areas: the technical and the creative.

## What are the best settings to use for portraits?

Although there is no one answer, the classic approach to portraits is to use a shallow depth of field to throw the background out of focus, so try the following options to get you started:

- **File type:** Raw (for highest quality).
- **Focal length:** 85–135mm (a mild telephoto).
- **Shooting mode:** Aperture Priority (to control the aperture and depth of field).
- **Aperture:** f/4 or wider.

- **Shutter speed:** 1/125sec. to avoid camera shake when shooting handheld (image stabilization will allow for slower shutter speeds); faster if the subject is moving.
- **ISO**: as low as possible to achieve the appropriate aperture and shutter speed.
- **Focus:** Single-Shot AF with single AF point (focus on subject's eyes).
- **Burst mode:** Single Shot.
- **White balance:** Auto (Raw format allows the white balance to be changed during processing).

## ⟳ I saw some great backlit portraits with heavy lens flare – how can I re-create that look?

To cause lens flare you need to encourage stray light to hit your lens and bounce around inside it. That means shooting towards the light (possibly even including the light source in the frame) and taking off your lens hood. If you're really keen, consider using a vintage lens, as the coatings designed to combat flare were less effective in the 'old days' and will have been worn away from years of cleaning, making them even more susceptible to flare. If none of this works, then consider adding flare digitally – you'll need to shoot towards the light to make the effect convincing, but if it's good enough for all those Hollywood blockbusters...

▲ Aiming your lens towards the light is the first step in creating lens flare.

### ✿ I've been photographing my local church for its website, but all of the shots I take inside are either too dark or the windows are too bright – can I fix this?

Sometimes, the dynamic range of a scene – the difference between the brightest and darkest areas – is just too much for a camera to manage in a single shot, and this is really common when you shoot indoors and have windows or open doors in the frame. Assuming you can't light the interior of the building, your best bet is to shoot several exposures and blend them with your editing software. I'd start by shooting a series of bracketed exposures (see page 59) so you have one shot that's exposed for the interior, another for the

windows and one in between. You could then either combine these to create an HDR (High Dynamic Range) image, or blend them manually using layers and masks to take the 'best' bits from each exposure (see pages 158–59). If you choose to take the HDR route, most editing programs have an HDR option, or you can use a dedicated program such as Photomatix Pro.

## ◌ I saw some shots of my city at night and the street lamps had a cool 'star' effect – how can I achieve this in my photos?

Starburst filters in front of the lens are a surefire way to create this love-it-or-hate-it effect. These filters typically have a number assigned to them that indicates the number of 'points' it adds, so a starburst 4 filter will produce a four-point starburst, a starburst 6 gives you six points and so on.

Alternatively, try shooting with a small aperture setting in the region of f/16–f/22. You'll need a tripod if you're shooting at night, but as the light gets forced through the small aperture it can create a dramatic star effect where there are point light sources such as street lamps, or even the sun during the day if it's small in the frame. Different lenses and aperture settings give different results, so play around to see what works best.

▲ Shooting a range of different exposures and combining them to create an HDR image is one way of dealing with high-contrast scenes, but not everyone likes the HDR look. Manually blending an exposure sequence is often more subtle.

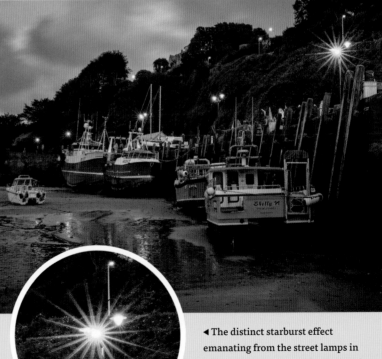

◀ The distinct starburst effect emanating from the street lamps in this image were created by closing the aperture on the lens down to f/22 – no filters necessary!

# ⚙ How do I photograph a sunset?

As the sun goes down and the sky is transformed by a fiery dance of light, photographers the world over line up to record this natural spectacle. Many come away with photographs that are – quite literally – a pale reflection of the event, with all of the vivid hues somehow washed out when their shot was taken. However, it's not too difficult to ensure the intensity of your photographs matches the vibrancy of the spectacular sunset you are seeing – try these tips:

- Colour is one of the most important features of a sunset, so before you do anything else, switch your camera's white balance to its Daylight ('sunny') setting. Steer clear of Auto white balance or your camera will try and remove the overly warm orange/red colour of the sunset, thinking it's a colour cast.

- The next critical consideration is the exposure. You want to make sure you expose for the relatively bright sky and not the darker ground beneath it – exposing for the ground will almost certainly give you a washed-out sky. A good option here is to switch to spot metering and aim your lens at a point in the sunset sky that isn't too bright and isn't too dark, so not the sun and not a dark cloud – a patch of clear sky maybe 10–15 degrees above the sun is often a good spot. Alternatively, use multi-area metering and negative (–) exposure compensation to dial down the exposure – start by setting –1 stop of compensation and take it from there.

- The previous steps will get you a vibrant sunset, but chances are the ground will be too dark. If that's okay, then great, but if you want a better balance between the exposure for the bright sky and the darker ground you'll need to get technical. One option is to use a neutral density graduated filter (or **ND** grad), which will darken the exposure for the sky without affecting the brightness of the ground, or you can make two different exposures – one for the sky and another for the ground – and combine them when you process your images. In either case, a tripod will help keep things steady as the light slowly fades.

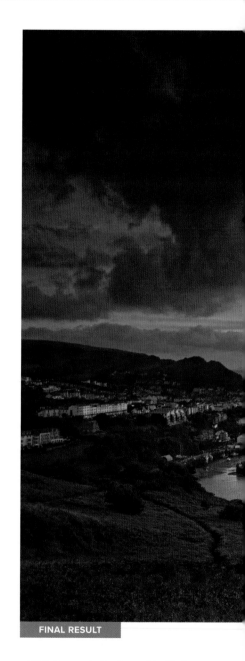

**FINAL RESULT**

▲ With the sun in the frame I decided to use a 3-stop ND grad filter and multiple exposures to achieve this shot. On its own, the filter simply wasn't strong enough, but it enabled me to cover the dynamic range of the scene in just three shots.

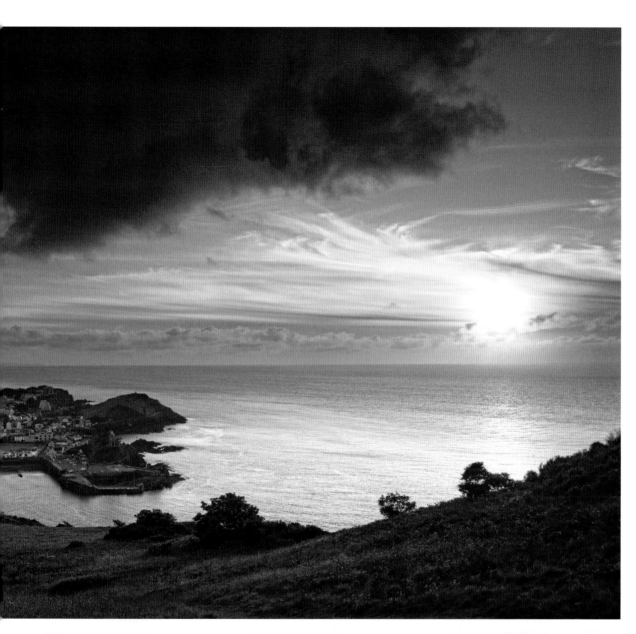

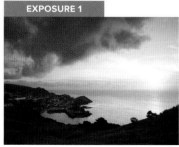

**EXPOSURE 1**

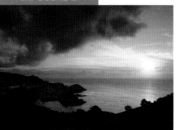

**EXPOSURE 2**

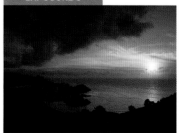

**EXPOSURE 3**

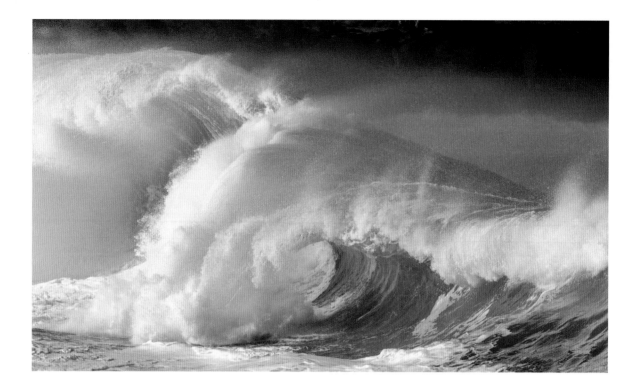

## How can I photograph waves?

Although transforming waves into a 'mist' can create a beautifully serene image, to capture the power of crashing, foam-flecked surf you really need to freeze the action. These top tips will get you started:

- The warm light at either end of the day is ideal for giving your surf shots an attractive glow.
- Watch the weather forecast, and check the state of the sea. An offshore breeze will help create more impressive waves and dramatic spray.
- If the conditions are going to be really wild, consider a rain cover for your camera to protect it from the salty spray.
- Shoot Raw so you have the best image for processing – you may need to rein in the contrast or pull back the highlights in the sparkling white spray.
- Use a telephoto lens. The best focal length will depend on how far the waves are from the shore when they break and how big they are, but 200mm is probably going to be the minimum you'll need.

▲ A telephoto lens allows you to fill the frame without getting your feet wet. However, shooting waves from in the water (with a waterproof camera or housing) will really put you at the heart of the action.

- Shutter Priority is your go-to exposure mode. Dial in a shutter speed of 1/1000sec. or faster and adjust the ISO so your camera's giving you an aperture setting of f/4 to minimize the depth of field.
- Set your camera's autofocus mode to Continuous so it 'tracks' the waves. This will help ensure the waves are sharp when you shoot.
- Your camera's Burst mode (or Drive mode) should be set to Continuous as well, so you can take a sequence of shots.
- As the wave is about to break, rattle off a short burst of frames to cover the action and – hopefully – capture the perfect moment.

# ⚙ How do I create 'silky' water?

All you need to achieve this is a rock-steady camera (a tripod is essential) and a suitably long exposure time — perhaps even lasting several minutes. A lot of manufacturers now make neutral density (ND) filters that are specifically designed to give you the look you're after by reducing the amount of light passing through the lens by 10 stops or more (in real terms, a 10-stop ND filter would transform an unfiltered exposure of 1/15sec. into a 60sec. exposure).

Using these filters isn't as straightforward as regular shooting, though. For a start, your camera's auto focus won't be able to 'see' through the filter, so you will need to focus before you fit it and then switch to manual focus so your camera doesn't try and adjust anything. You may also find that you're working outside your camera's exposure metering and shutter speed range. This means you will need some sort of exposure table that converts a normal, unfiltered exposure time into a long exposure

(there are plenty of these online), and that you might have to switch to Bulb mode and manually start and end the exposure. If this is the case, a remote release for your camera will also be needed so you don't have to touch, and potentially 'shake', the camera.

▼ I used a 3-stop neutral density (ND) filter over my lens for this shot, in conjunction with a low ISO setting and a small aperture. The result? A 4sec. exposure in daylight that transformed the fast-flowing water into a silk sheet.

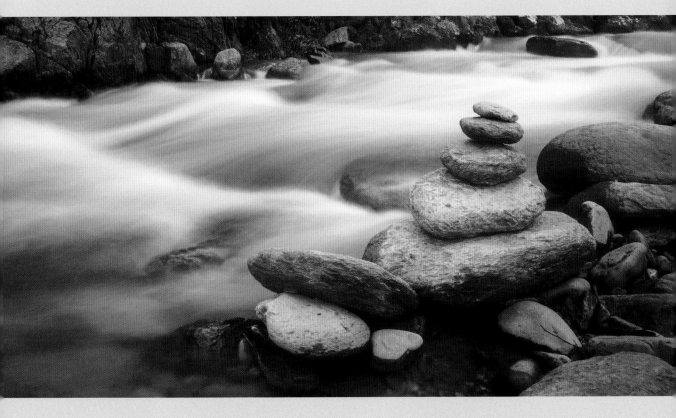

## ⟳ Can I shoot in the rain, or am I better off keeping my camera indoors?

If your camera is 'weatherproofed', like many mid-to-high-end DSLR and mirrorless models, then a brief rain shower is unlikely to do it much harm, but what about your lens? If that isn't weatherproofed as well water can get in (especially around the lens mount), just as it can if you change the lens, battery or memory card on your wet camera. Don't let this put you off, though, as there are plenty of rain covers available that are specifically designed to keep your camera dry, even in quite ferocious conditions. This type of cover is also useful when it comes to protecting your kit from sand and spray at coastal locations, or in any other situation where you want to protect it from the elements.

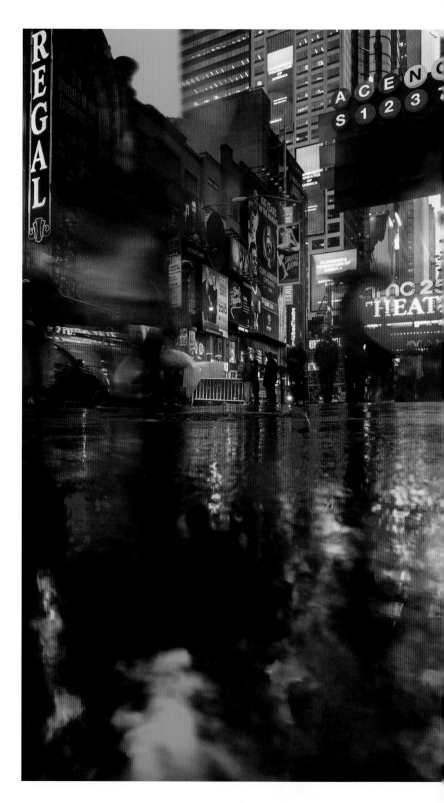

▶ If you don't want to risk shooting in rain, wait until it's stopped – wet roads can create dramatic reflections, especially at night.

## ◎ How can I create a perfect silhouette?

Silhouettes are essentially about showing your subject as a featureless black shape, so the form is the focus of the shot. This can work with anything from ruined buildings to portraits, but the best silhouettes tend to be the ones that have a recognizable subject. This means choosing something that remains 'readable' when it's reduced to a simple shape and isolating it – overlapping elements can easily create a confusing image. You then need two things: a relatively bright background that your subject will stand out against, and a carefully set exposure. Your background can be anything from the sky to a bright wall, but the key is that it needs to be brighter than your subject; the more extreme the difference in brightness is, the more pronounced the silhouette will be.

You then need to nail the exposure, and the trick here is to set your exposure for the background, rather than the subject. Using your camera's spot metering mode is a great way of doing this (see page 55), or you can apply 1–2 stops of negative exposure compensation to help prevent your dark subject making the exposure lighter than it should be. Remember, if you shoot Raw you can also tweak the contrast when you process your shot, which is great if the difference in brightness between the background and your subject isn't as high as it needs to be.

▲ Shooting towards the sun on a wet sandy beach gave me a bright sky and an almost equally bright ground – perfect for picking out silhouetted figures with a telephoto lens.

## ◌ How can I photograph animals in a zoo?

With a lot of modern zoos, viewing platforms and relatively open enclosures are the order of the day, so you can photograph the residents without too much difficulty. But when it comes to photographing through wire fencing things can get a little trickier and there's nothing worse than having an otherwise great shot marred by a shadowy 'mesh' texture over it. To avoid this, get as close to the fence as you can and set your lens to its widest aperture. As long as your subject isn't right up against the fence, the shallow depth of field and close proximity of the wire should be enough to make it 'disappear' from your photographs. The same technique will also work if you're photographing from inside the safety cages found at the top of a lot of tourist viewpoints.

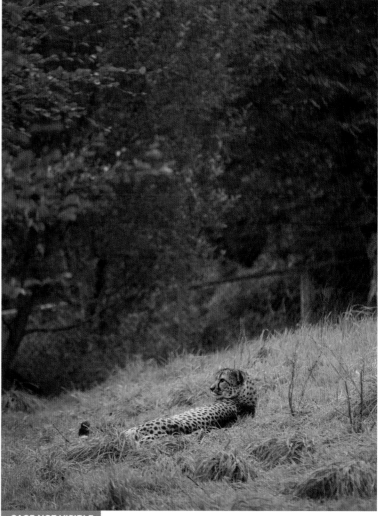

CAGE NOT VISIBLE

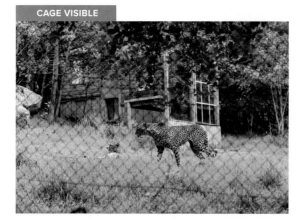

CAGE VISIBLE

◀ ▲ Taken at my local zoo, the first shot of a pair of leopards has nothing going for it: the background is distracting, the composition is loose and there's just no getting away from the mesh fence covering everything. However, getting closer to the fence and shooting with a wide aperture made the mesh 'disappear'. It's a shame there's still a fence in the background, but the shot's a whole lot better.

▲ Definitely not a pet, this puma was photographed at the zoo by pressing my lens hood up against the thick, dirty glass to prevent any reflections. The same technique works if you're shooting through glass on a building's observation deck, or through a window.

## ⟳ How can I avoid reflections when I'm shooting through glass?

Whether you're shooting through a window or through a glass tank in an aquarium, reflections can quickly ruin a shot. Thankfully, they are relatively easy to avoid if you can get up close to the glass and shade your lens and the glass from any extraneous light. A simple and free way of doing this is to put your jacket over your head and your camera/lens to create a kind of tent that shields you and the glass you're shooting through, although this isn't ideal in busy locations, and isn't always successful.

A more effective solution is to buy a dedicated Lenskirt (or similar), which is a large fabric lens hood that you attach to your lens and then stick to the glass with suckers; it will block out any reflections, but it's quite expensive for something with only one real use. My personal preference lies between the two options in the form of silicone rubber lens hoods. They're smaller and cheaper than a Lenskirt, and more reliable than a jacket – just press the front of the hood against the glass to create a light-tight seal and your reflections will disappear.

## ⟡ How can I take great photographs of my pet?

All pets are different, not only in terms of species, but also their individual demeanour, so there are no hard-and-fast rules here. There are, however, some things you can do that will help you get the best results from animal encounters:

- Accept that your photography is going to be on their terms, not yours. When they've had enough, your shoot is over – try again later if you need to.
- Shoot handheld so you've got full camera movement.
- Animal portraits can be treated in a similar way to human portraits, so use wide apertures for minimum depth of field and focus on the eyes.
- For action shots, think of yourself as a sports photographer: fast shutter speeds will freeze motion, but also try panning to create a sense of speed.
- You know your pet best, so you'll know how tolerant it is. Bear this in mind when determining your lens choice and working distance. Generally speaking, the closer you are to your subject, the shorter your shoot time is likely to be, so keep your distance if you can.
- If you're shooting indoors, try and work near a window so you've got plenty of light. Alternatively, you could set up an off-camera flash and bounce it off the ceiling, although some pets won't stick around after that first sudden burst of light.
- Shoot from their level, not yours. Getting down to your pet's eye level is a great way of creating a connection and showing how they experience the world.
- Pet toys tend to be brightly coloured, which can be visually distracting, so make sure there aren't any toys or chews in the background that are going to draw attention.
- Avoid sudden moves and loud noises.
- Use vocal 'clicks' and 'chirrups' to get your subject's attention if you want eye contact, or use toys or snap your fingers out of shot to direct their gaze elsewhere.
- Say thank you – a few treats and cuddles is the least you can do to pay your model for their time!

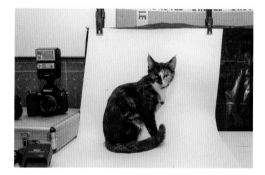

▲ I had set up to take some quick shots of film cameras for a book I was writing (yes, my setups really are that low tech!) when one of our kittens decided to pay me a visit.

◀ No sooner had I grabbed a couple of shots when her sister decided it was her turn, enabling me to create a pair of semi-formal pet portraits. Sometimes you just have to let your model guide you!

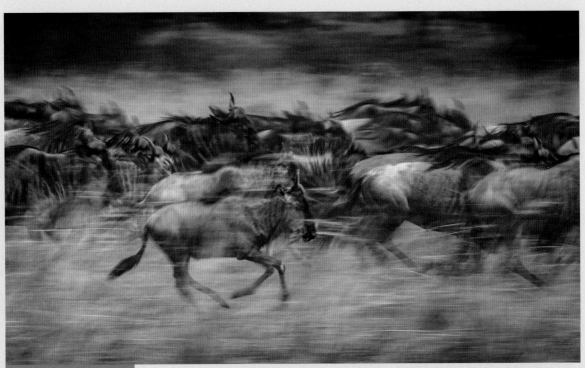

SLOW SHUTTER SPEED

## ⟲ What are the best settings to use for wildlife?

Depending on your subject, photographing wildlife can be similar to shooting portraits or more like taking sports shots. These are some of the best settings to use for wildlife photography:

- **File type:** Raw (for highest quality).
- **Focal length:** 300mm or longer (depends on subject).
- **Shooting mode:** Aperture Priority (for animal portraits when background blur is important); Shutter Priority (for moving subjects).
- **Aperture:** f/4–f/5.6 (to blur backgrounds).
- **Shutter speed:** 1/1000sec. or faster to freeze motion; 1/125–1/250sec. for panning shots.
- **ISO:** Auto (capped at ISO 1000 to avoid too much noise).
- **Focus:** Auto AF (will switch from Single Shot to Continuous if subject starts to move) with a single AF point (use a central AF point, as it is typically the fastest-focusing).
- **Burst mode:** Continuous shooting (to allow a rapid sequence of shots).
- **White balance:** Daylight or Cloudy preset, depending on conditions (fine-tune when you process your Raw files).

FAST SHUTTER SPEED

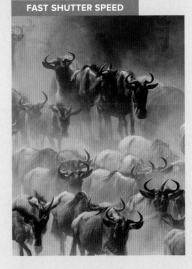

▲ With moving wildlife, your choice of shutter speed will determine the look of your shot: fast shutter speeds freeze movement, slow shutter speeds lead to motion blur.

## ✦ What are the best settings to use for landscapes?

There are no definitive settings for any type of photograph, but the following will get you started if landscapes are your thing:

- **File type:** Raw (for highest quality).
- **Focal length:** scene dependent.
- **Shooting mode:** Aperture Priority (to control depth of field).
- **Aperture:** f/16 (any smaller and diffraction can be an issue; any wider and you lose depth of field).
- **Shutter speed:** the camera will decide this, but watch out for camera shake if shooting handheld.
- **ISO:** if you're using a tripod, use the lowest native setting (ISO 100–200); if shooting handheld, set the ISO as low as possible to give you a shake-free shutter speed (see page 67).
- **Focus:** Single-Shot AF with a single AF point (consider using the hyperfocal distance, as outlined on page 136).
- **Burst mode:** Single Shot.
- **White balance:** Daylight or Cloudy preset, depending on conditions (always Daylight at sunrise and sunset to maintain the colour in the sky).

▲ This sunrise shot epitomizes the classic landscape approach, with a wide-angle focal length and extensive depth of field. However, it breaks from tradition in that it was shot on out-of-date film, which skewed the colours and added grain – not something you'd get if you shot at a low ISO on a digital camera.

## ⟡ What are the best settings to use for sports?

Sports photography is often about capturing split-second moments, so speed is paramount, whether it's the shutter speed you use, focusing as quickly as possible or shooting as many frames as you can in rapid succession. These are some of the best settings to use when you're photographing sports:

- **File type:** highest quality JPEG (to avoid the camera's buffer filling up; see page 134).
- **Focal length:** 200mm or longer (depends on subject).
- **Shooting mode:** Manual (to control aperture and shutter speed).
- **Aperture:** f/4–f/5.6 (to blur backgrounds).
- **Shutter speed:** 1/1000sec. or faster to freeze motion; 1/125–1/250sec. for panning shots.
- **ISO:** Auto (it's better to have a noisy shot than a blurred one, so ISO is secondary).
- **Focus:** Continuous AF to track moving subjects, with a single AF point (use a central AF point, as it is typically the fastest-focusing); for ultra-fast subjects such as in motorsports, switch to manual focus and pre-focus, as outlined on page 74.
- **Burst mode:** Continuous shooting (to allow for a rapid sequence of shots).
- **White balance:** Incandescent or Fluorescent preset if shooting indoors; Daylight or Cloudy preset if shooting outside (take a test shot to check).

◀ ▼ Taken during the same motorcycle race, different shutter speeds recorded the action in different ways. My favourite is the one that's most heavily blurred – nothing in the shot is sharp, but it conveys the energy of the event.

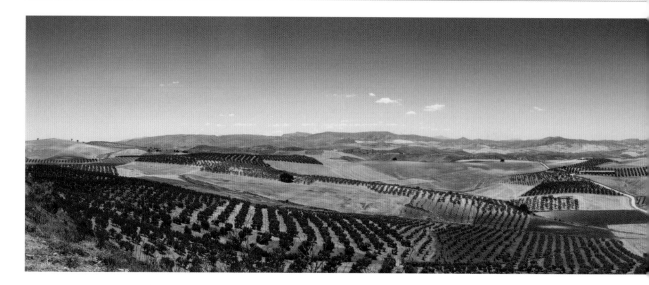

## ⚙ How do I shoot a panoramic image?

The easiest way of creating a panoramic image is to take a shot and crop it, but a better option is to make multiple exposures and stitch them together. This could be as simple as taking two landscape-format shots and joining them together to widen the view, or as complex as taking multiple portrait-format shots that you can then stitch together to create an ultra-high-resolution panorama. In either case, the underlying process is the same:

- Shoot Raw for maximum quality and set the white balance to a suitable preset so it won't change.
- Switch to Manual (M) mode so your exposure won't change between shots. It doesn't particularly matter what your exposure settings are (it's primarily shot-dependent), but watch out for any moving elements that may create inconsistent motion blur between frames. If you're shooting handheld, make sure the shutter speed is fast enough to avoid camera shake as well.
- Focus manually (again to ensure this doesn't change between shots).
- Once you've taken a test shot or two to decide your exposure, shoot the first frame of your panorama. It's a good idea to start at the left end of your scene.
- Turn the camera to shoot the second frame of your scene. Ensure there's a good overlap between this frame and the previous one so your software can align them easily. If you're shooting handheld, try and make sure you turn the camera horizontally, and don't start drifting up or down as well (a tripod is a better option).
- Shoot additional frames as necessary, again ensuring a good overlap.
- Process your Raw files in exactly the same way, so they remain consistent.

SEQUENCE OF 13 INDIVIDUAL IMAGES

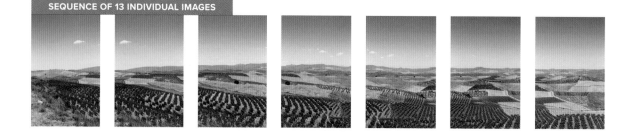

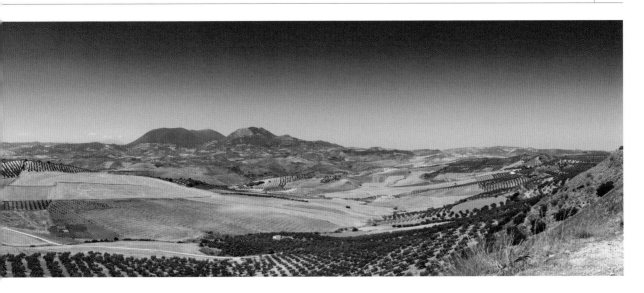

- Although Adobe Photoshop and Adobe Lightroom have panoramic stitching tools built in, it's not a standard feature in a lot of image-editing programs, so you may need to use a dedicated app. There's a wide range available – just search for 'photo stitching software' online and take your pick.
- Then, upload your individual images and let the software transform them into a single panoramic photograph.

▲ ▼ This panorama was created from a sequence of 13 'upright' images, shot handheld. Because I shot manually and overlapped the images, Photoshop had no problem combining them into a seamless panorama that I could then crop and colour using the image-editing program Exposure.

**INITIAL MERGE IN PHOTOSHOP**

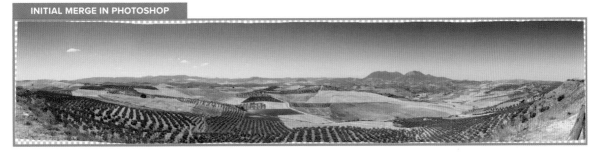

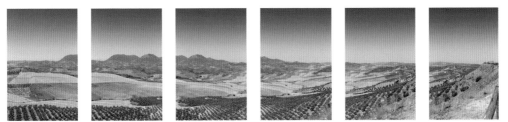

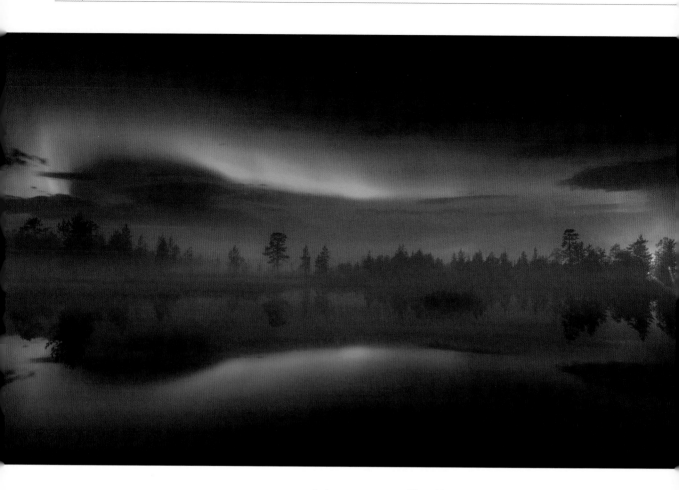

▲ A view across water will enable you to capture reflections of the aurora.

### ◐ I'm going on a once-in-a-lifetime cruise to the Arctic Circle and I want to photograph the Northern Lights – how should I do it?

As with a lot of night photography, taking full control of your camera is essential if you want to photograph the aurora borealis. That means focusing manually, setting the white balance manually to the Daylight preset (and shooting Raw so you can fine-tune this if necessary), and, of course, choosing the Manual (M) shooting mode so you have full control of the exposure. You'll also need a wide-angle lens so you can make the most of the spectacle, and a tripod to keep everything steady.

When it comes to your exposures, you want to be shooting with an aperture of f/2.8–f/4, so you'll need a fast lens – a kit zoom might not quite cut it here. There are no hard-and-fast rules when it comes to choosing the ISO and shutter speed, as a lot will depend on the speed and intensity of the aurora. Start with the ISO set to 800 and a shutter speed of 5–10sec. for bright, fast auroras; 10–20sec. for slower-moving displays; and 20–30sec. for faint lights. Check the histogram after you've taken a shot and adjust your ISO and/or shutter speed from there.

# ◐ Why does my snow look grey?

Whenever your camera gives you an exposure reading, it starts by measuring the intensity of the light being reflected off your subject: it doesn't matter if you're using the most advanced multi-area metering pattern or spot metering, the process is the same. In each case, the camera then assumes that whatever it is basing its light reading on is mid-grey in tone (regardless of its colour) and sets the exposure accordingly. A lot of the time this works well, especially when you use a multi-area metering mode that reads the scene as a whole, because – surprisingly perhaps – a lot of scenes and subjects average out to the mid-grey ideal that the camera is looking for. But faced with a predominantly bright subject like snow, your camera can easily get this wrong. This is simply because it doesn't know what it's looking at and is programmed to give that mid-grey average, no matter what. In the case of snow (and bright, sandy beaches) this means that all those sparkling whites can come out looking darker than they should. The same thing will also happen with overly dark subjects, just in reverse, so images start looking a bit too light.

Thankfully, there are several solutions. The first is to use exposure compensation, which will usually work in any mode except Auto or Manual. How you apply exposure compensation will depend on your camera, but a positive adjustment of +1½–2 stops will usually be enough to ensure your snow is transformed from grey to white when you shoot. Alternatively, if you're shooting in Manual mode, switch to your camera's spot metering mode, take an exposure reading from the brightest patch of snow and increase the exposure by the same 1½–2 stops, either by setting a slower shutter speed or by opening up the aperture (or a combination of both). In either case, take a test shot and look at the histogram on the back of the camera – the graph should be shifted towards the right, indicating a mass of light areas, but it should not be crashing off the scale (which would tell you your whites are overexposed and featureless).

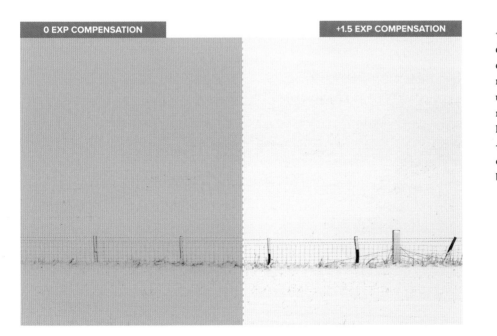

0 EXP COMPENSATION

+1.5 EXP COMPENSATION

◀ Left to its own devices, my camera's multi-area metering mode underexposed this minimalist, snowy landscape; it took +1½ stops of exposure compensation to brighten things up.

## How do I focus for close-up shots?

I love close-up and macro photography and over the years I've tried plenty of different close-up tools. The easiest option – and the one I use most often – is a dedicated macro lens, which gives 1:1 (life-size) reproduction, but this is by no means the only solution. When I started out, I used supplementary close-up lenses that fitted to my film SLR's 50mm prime lens like filters. This is a low-cost way to get into close-up shooting, and it lets you make use of all of your camera's auto controls. The image quality isn't always that great, though, especially if you start to use multiple lenses to get super-close.

Alternatively, you can use extension tubes or bellows that fit between the lens and camera and will let you focus in much closer to your subject. However, dedicated electronic tubes and bellows that let you use your camera's auto focus and auto exposure tend to be quite expensive, while simplified versions require you to set your exposures manually, using a lens with manual aperture control. In either case, tubes and bellows work best with a prime lens, so that might be an additional expense – a 50mm prime is usually ideal, although I use my bellows with an old enlarger lens.

▲ Close-up lenses that attach like filters, extension tubes and macro bellows can all be used to take macro shots, but my go-to option for general close-up work (such as for the above shot of a toy cowboy) tends to be a dedicated macro lens.

# What are the best settings to use for photographing a city at night?

Street lighting and the lights from buildings can create dramatic night-time images, especially if you shoot just before sunrise or shortly after sunset when the sky's a deep complementary blue colour. Try these settings to get started:

- **File type:** Raw (for highest quality).
- **Focal length:** scene dependent.
- **Shooting mode:** Aperture Priority (to control depth of field).
- **Aperture:** f/16 (to create a starburst effect and/or record light trails); f/4 (for a faster shutter speed to minimize motion blur).
- **Shutter speed:** the camera will decide this (activate image stabilization if you're shooting handheld, or use a tripod).
- **ISO:** 400.
- **Focus:** Single-Shot AF with a single AF point (switch to manual focus if the AF struggles).
- **Burst mode:** Single Shot (consider shooting a sequence of bracketed exposures for HDR if the dynamic range is high).
- **White balance:** Daylight preset (to allow artificial lighting to reveal its true colour temperature).

▲ With bright lights and dark shadows to contend with, shooting a sequence of exposures to blend together manually or using HDR imaging software can work well for night-time city shots.

▶ To take your firework shots to the next level, think about shooting separate exposures for the foreground and fireworks to combine in your editing software, or combine shots of multiple firework bursts to give the display added intensity – it doesn't all have to be done in a single shot.

## How can I nail my firework photos?

Photographing fireworks often seems harder than it is, but it really just boils down to letting the fireworks 'paint' an otherwise dark scene with light. The same setup will also work with photographing lightning at night – here's how to get started:

- Set your camera up on a tripod, with a good view of the display area. It pays to arrive early so you not only get a good spot, but can also frame your shot while it's still light enough to see.
- Focus at infinity, either by using your camera's AF and then switching to manual focus to 'lock' the distance, or by focusing manually to start with.

- Switch to Manual (M) shooting mode. Set the ISO to its lowest setting and the aperture to f/11. The shutter speed needs to be set to Bulb (B), which is usually found after the camera's slowest shutter speed (often 30sec.)
- When the display starts, press the shutter-release button to start your exposure, wait for an aerial explosion or two and then press the shutter-release button to end the exposure (it's a good idea to use a remote release here as it will mean you don't accidentally knock your camera).
- If your images are too bright, use a smaller aperture; if they're too dark, open it up by a stop or two, or increase the ISO.

## 🔆 What's the best way to photograph star trails?

We tend to see stars as pinpricks of light in the night sky, but get creative with your exposures and you can transform these bright dots into spectacular trails of light that record the Earth's rotation. There are two options here: make a single long exposure or take multiple shorter exposures and combine them. A single exposure is the easiest option, but it's not going to give you the best results as ultra-long exposures build up heat on the camera's sensor, which generates noise in your images. So, as long as you don't mind a bit of processing work, making multiple exposures and 'stacking' your images is usually preferable. Here's how it's done:

- Set your camera up on a tripod.
- Shoot Raw, with the white balance set to Auto.
- Focus your lens manually at infinity.
- Switch your camera to Manual (M) mode and make sure noise reduction is switched off.
- Set your lens to its widest aperture setting (f/2.8 is ideal) and dial in ISO 800.
- Set the shutter speed to 30sec. (typically the longest 'timed' shutter speed) and take a test shot. Use a remote release to avoid camera shake.
- How do the stars look? If they're too bright, reduce the ISO to 400; too dim, increase the ISO to 1600.

If the stars are still too dim at ISO 1600, switch your camera to Bulb (B) mode and time your exposures manually, rather than increasing the ISO any further.
- Once you have established your exposure settings, start making your individual exposures – the more you make, the longer your star trails will appear in your final shot.
- As soon as one exposure ends, shoot again without delay to avoid having any gaps in your star trails. A camera with a built-in intervalometer is useful here, as it can be programmed to shoot a continuous sequence of exposures.
- Open your Raw files in your editing software and adjust the white balance and other settings (if necessary). Make sure you apply identical adjustments to all of the images in your sequence.
- Export the processed Raw images as high-quality JPEGs.
- Although you can stack your exposures in Adobe Photoshop, a simpler option is to use StarStaX (www.starstax.net). This is a free program for Windows and macOS designed specifically for this type of work, which will convert your individual exposures into a single star trail image.

◄ Having something in the foreground of your star trail images can help anchor the image and provide context, while light pollution can add colour (although this can also be a distraction).

## ◐ I've been trying to shoot the moon, but my results aren't great – any advice?

The moon is brighter and moves more quickly through the sky than you might think, so the two most common issues (aside from not being able to get close enough) are motion blur and overexposure. A good starting point is to switch your camera to Manual mode and set the exposure to 1/125sec. at f/8, with the ISO at 100 (or ISO 200 if that's your camera's lowest setting). Take a test shot and assess the histogram to make sure your highlights aren't 'blown'. If they are, choose a faster shutter speed and shoot again. However, if your shot is too dark, raise the ISO or use a wider aperture – do not increase the shutter speed, as this increases the risk of slight motion blur.

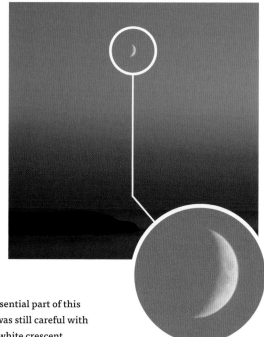

▶ A telephoto lens (or telescope) isn't the only option. The moon is an essential part of this twilight shot, yet only occupies a small part of the frame. Despite this I was still careful with my exposure to ensure it held some detail and didn't just 'burn out' to a white crescent.

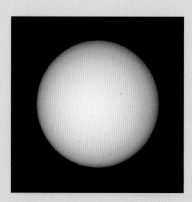

▲ With the right kit you can take photographs of the sun, but they're rarely as interesting as the craters on the moon.

## ◐ Is it possible to take pictures of the sun?

Any discussion about photographing the sun has to come with a whole host of warnings: looking at it directly can cause irreparable damage to your camera equipment and your eyes, so you should never (ever) consider just aiming your camera at that fiery ball and taking a snap. Include it as a small element in a landscape, yes, but don't zoom in and try and make it your main subject. Having said that, photographing the sun is certainly possible, but you will absolutely need a specialist solar filter for your lens, which will not only make the sun appear darker, but will also filter out invisible infrared (IR) and ultraviolet (UV) radiation. Even with the filter on your camera, you should still use the rear LCD to frame your shots, not the camera's viewfinder.

As far as shooting goes, aim to shoot just after sunrise, when the atmosphere is at its 'cleanest', as this will give you the clearest views. Set your camera up on a tripod, using a telephoto lens with a focal length of at least 200mm, or even a telescope. As with moon shots (see above) set the focus and exposure manually – start at 1/250sec. at f/8 and your camera's lowest ISO setting and make adjustments from there.

## ⟳ I was taking pictures in the street when the police stopped me and told me to delete all my photos – can they do that?

It all depends where you were and what you were photographing, as the laws around street photography vary between countries. While it might be okay to photograph people in public where you live, it might be unacceptable – or even illegal – to do the same thing elsewhere, so the best thing you can do is head online to get the lowdown on the country, region or even the town or city where you intend to pound the pavement with your camera.

Generally speaking, though, photography is always forbidden around military installations and other sensitive sites (armed guards are usually a good sign that you don't want to be taking pictures), and it is more likely to

be acceptable in public spaces rather than private ones. However, the distinction between 'public' and 'private' isn't always clear-cut: shopping malls are almost always private spaces, even though the public is allowed into them, and supposedly public parks and other recreation areas can also fall into the private category, with restrictions on what can and cannot be done – including photography. If in doubt, try and check with the owner or staff of any property you want to photograph on or around.

▲ Generally speaking, it's okay to photograph people in a public area – such as a public street – but if you're travelling somewhere new, it's worth checking to see if there are any local rules.

## ⚙ I like to shoot sports, but my camera keeps 'freezing' – why does this happen?

This all comes down to your camera's buffer. The buffer can be thought of as a 'waiting room' in your camera, where your images go immediately after they've been shot, but before they're written to the memory card. If you shoot JPEGs or make exposures at a relatively slow rate, you won't notice your images going in and out of the buffer because the data is cleared faster than it arrives. However, shoot a high number of images in rapid succession – especially Raw files – and data is sent to the buffer faster than it can be moved to the memory card, so the buffer starts to fill up. If the buffer becomes full, then your camera has to take a break so that some of the images can be cleared before it can shoot again – that's the 'freezing' that you're experiencing. To prevent this, try limiting your bursts of shots slightly and/or think about the size of the images you are shooting – maybe you can switch from Raw to JPEG for your sports shooting?

▲ The last thing you want when you're trying to shoot a game-winning catch or other split-second moment is for your camera to freeze up, so switch to shooting JPEGs and practise firing off short bursts of shots.

## ⚙ A friend has asked if I can take some shots for their jewellery company's website, but what would I need?

The main challenge you will have is controlling reflections that can easily detract from the piece you're photographing. In a pro studio, multiple lights, softboxes and reflectors might be used, but a simpler solution is to use a light tent. This is essentially a semi-translucent white box, usually made of some sort of fabric or plastic, with one 'wall' removed or a hole in one side for your lens to peek through. The idea is that you set up your lights – be it flashes or continuous lamps – outside the tent, and its walls act as both diffusers and reflectors, softening the light passing through them and bouncing it off the tent's wall opposite to create seamless white reflections in your item.

Depending on the size of the item you're photographing, you might even be able to use a mini light tent, as shown here, which comes with built-in USB-powered LEDs. It's a long way from being a 'pro' piece of kit, but for the ultra-low price it could be all you need to do a favour for a friend.

▲ This light tent cost me less than £10 online and comes with built-in USB-powered LEDs. It's not particularly big, but it's handy for shooting reflective subjects without any fuss.

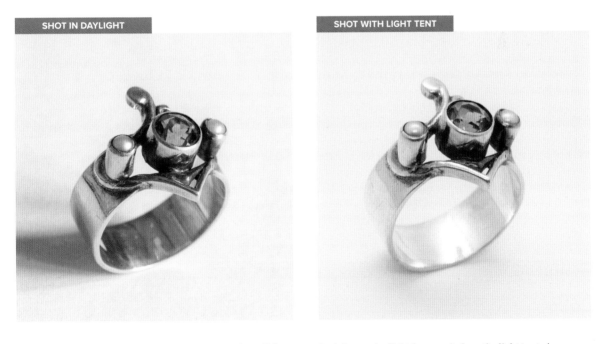

SHOT IN DAYLIGHT

SHOT WITH LIGHT TENT

▲ These two shots show the difference between using a light tent and relying on daylight from a window: the light tent gives a 'cleaner' image with fewer reflections and shadows.

▶ Using the hyperfocal distance for this shot enabled me to shoot with an aperture of f/8 – the sharpest aperture setting on this particular lens – while still keeping everything sharp.

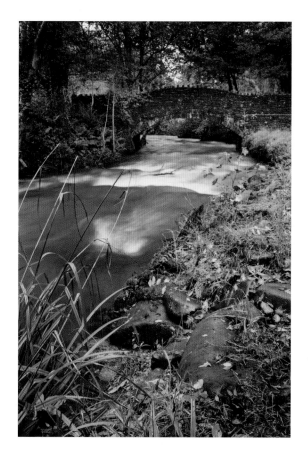

## How do I make sure everything in my landscape shots is in focus?

Although a small aperture and its correspondingly large depth of field will help keep everything looking sharp, the distance you focus at can also affect how much appears to be in focus. This is because the depth of field at any given aperture extends one-third in front of the focus distance and two-thirds behind it. Consequently, if you focus at infinity – the furthest focus distance on your lens, and the most common focus distance for landscapes – you are effectively wasting two-thirds of your depth of field, because there's nothing beyond infinity that could be any sharper.

However, if you focus on a point closer to you, you can bring the whole depth of field towards you, which means more of the foreground will appear sharp, while those distant elements will still be in focus as well.

The sweet spot is what is known as the 'hyperfocal distance', which is the focus distance where depth of field is at its maximum extent. When you focus at the hyperfocal distance, everything from half the focus distance through to infinity will be in sharp focus; so if the hyperfocal distance was 10 metres (33ft), everything from 5 metres (16½ ft) to infinity would appear sharp.

The good news is that there are plenty of websites and apps that will generate hyperfocal distance tables for pretty much every camera-and-lens combo, so you don't have to think about it too much.

## What's the best way to photograph glassware?

If you shine a light or fire a flash directly at a piece of glassware, the light is going to reflect straight back at you and create nasty white hotspots. So instead of lighting glass from the front, you're going to have to light it from behind. If you want it against a white background, then the simplest method is to set up a piece of white paper, card or foam board behind your subject and bounce your light off that; using a studio strobe with a softbox or a continuous lightbox behind the glass, pointing at the camera, will have the same effect. The darker surroundings of your room will naturally start to create dark outlines in the glass that help give it form, but you can make these outlines darker by positioning black card at either side of your subject, and perhaps above it as well. The result? A reflection-free piece of glass with lovely dark edges.

You can take this a step further by placing a piece of black card or board behind your subject, in front of the white background. The black board should fill the frame to create a black background for your glass, but shouldn't cover the white completely, because you're going to use the white surround as your light source. Use two lights – one placed at either side – aimed at the white border, with card 'flags' (panels) preventing light from falling on the black and turning it grey. Now, instead of a glass against a white background with dark edges, you'll have the exact opposite – a glass on black with white edges.

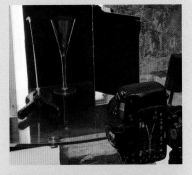

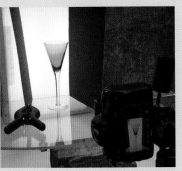

◀ I used a lightbox to light this glass from behind, but you could also use a strobe with a large softbox or fire a flash (or two) at a sheet of white card. Adding a black card 'flag' at either side introduced the dark outlines.

▶ To switch from a white background to a black background, I simply covered the centre of the lightbox with a piece of black card, leaving two narrow 'slits' of light either side, and then adjusted the black flags at the sides.

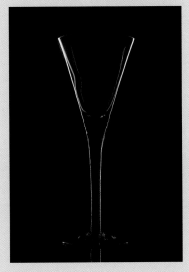

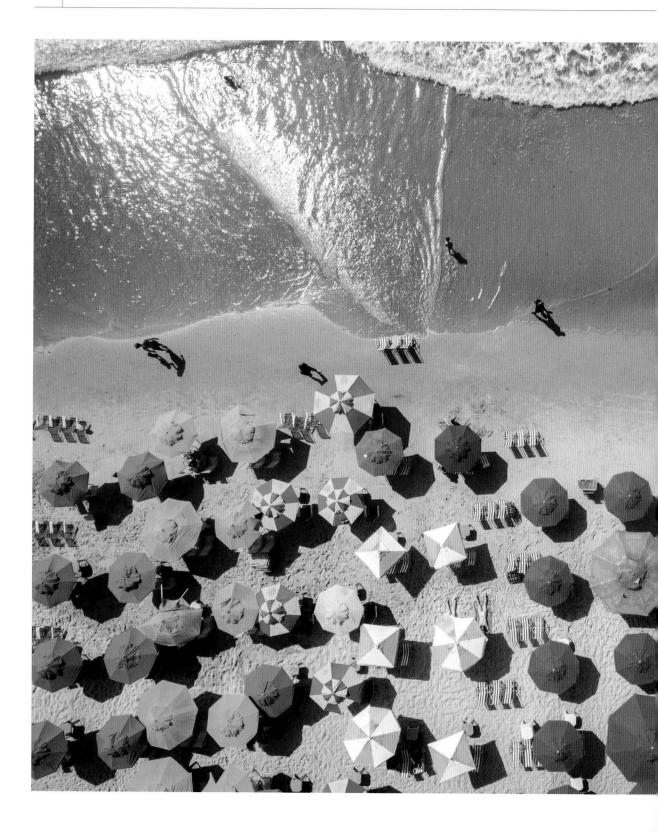

## ◌ What are the rules about using a drone?

Just like the rules on street photography (see page 133), the rules on flying a drone vary from region to region and are subject to regular change as the technology is used (and abused) in new ways. There are some rules that are pretty universal, though, and while you could describe them as common sense it's surprising how many people overlook them in pursuit of that 'perfect' shot:

- Always maintain a line of sight with your drone.
- Avoid flying near power lines.
- Never fly near airports or aircraft.
- Never fly near military bases and installations.
- Avoid flying over busy roads.
- Avoid flying directly over crowds of people.
- Don't go snooping around people's houses.

◀ You should always be aware of what's directly beneath your drone, because should the worst happen, it's only going to go in one direction – down!

# IN THE DIGITAL DARKROOM

Processing can help transform the shot you took into the masterpiece you envisioned, or simply optimize your image, ready for sharing.

# Hardware

From your phone to a desktop computer, there's a wide range of devices that you can use to process your pictures. Which one's right for you?

## ✦ What's the best computer for editing digital photographs?

Mac or Windows? Desktop or laptop? These debates have rumbled on for decades, and there is no right answer. Although Apple Macs are most closely associated with photography in the professional workplace, Windows PCs will do the job just as well, often at a lower cost, so don't get suckered into thinking a Mac is the only answer.

As for whether a desktop or a laptop computer is better, this is another either/or situation – some laptops outperform some desktop models, with the added benefit of letting you work wherever you like. However, if you go down the laptop route I'd still advise getting a large desk-based monitor that you could plug it into, so you can benefit from a big-screen that allows you to properly 'see' your images.

The main thing is that the computer you choose has plenty of RAM (memory) so it can push your pixels around without grinding to a halt. Around 8–16GB should be considered the minimum, especially with high-resolution cameras. A computer that uses a solid-state drive (SSD) as opposed to a traditional hard disk drive (HDD) will also run quicker while you work, although a high-capacity external hard disk drive is still useful for backing up your files – it will have slower read/write times, but speed is less of an issue when you're just backing up your files, so you may as well take advantage of an HDD's lower purchase price.

◄ ► As a general rule, a laptop computer will cost more than a desktop device with a similar specification, but they are great if you're shooting on location. Apple Macs tend to be the professional's choice, but high-spec Windows PCs are equally capable – most software will run on either platform.

▶ Editing photos on your tablet or phone is great for tweaking shots before you put them on social media, but this doesn't offer as much control (or finesse) as working on your images on a computer.

## ◌ Can I edit photos on my tablet or phone?

Although you can get image-editing apps for your mobile device – including Adobe Photoshop and Lightroom – I prefer to work on a computer. A lot of phones and tablets have great screens in terms of their resolution, but they are limited in terms of size, and it's not the same as sitting in front of a big monitor (or two) where you have plenty of screen real estate to view your images up close and personal. Psychologically, I also find that chaining myself to a desk and computer provides a more focused experience than working 'on the go' with a mobile device, so I concentrate more on what I'm doing. I like to think that leads to a better result.

## ⟳ I'm struggling to make accurate selections with my mouse – is there an easier option?

Personally, I've always used a Wacom pen tablet for editing work, because a pen is a more natural tool to hold and use, especially when it comes to making selections or using any of the brush-type tools. For selecting menu options and adjusting on-screen sliders there's no real benefit, though.

▲ I've been using a pen and tablet for more than 20 years now – for editing images I just can't use a mouse any more and 'touch' technology doesn't appeal.

◀ I use external hard drives for storage and backing up my files, as well as cloud storage via a subscription to Amazon Prime.

## ⟳ My computer's hard drive is filling up – where should I save all my photos?

For a start, you should always have an external drive that you back up your images to, so your once-in-a-lifetime shots are saved in at least two places. Some photographers make even more copies and will possibly store these drives in different locations to protect them all from being lost to fire, flood, theft or some other catastrophe. In addition, you could also consider cloud storage and upload your photos to a remote site – there are plenty of options here, including Microsoft's OneDrive, Apple's iCloud, Google One and Amazon Photos.

## ⟳ My inkjet prints come out looking quite different to the images on my screen – help!

Every time your prints come out too dark or too bright, or the colours don't look right, you're wasting ink, paper and time. Obviously, you could make a print, tweak the image and print again until you get the result you're after, but that's going to cost you more time and money. A better solution is to get your computer and printer set up so that what you see on your screen matches the prints that you make. The first step in this process is to calibrate your monitor, so you know the image you're looking at on screen is accurate in terms of its brightness, contrast and colour. Windows and macOS both have monitor calibration utilities built in, and there are plenty of free options to be found online, but they share one common shortfall: they all rely on you making decisions based on what you're looking at, and we all see things slightly differently. A much better option is to use a piece of hardware known as a 'colorimeter', which works in conjunction with calibration software to optimize your display and create a 'monitor profile' that ensures you are looking at an accurate image.

This could be all you need to do to fix your printing woes, but if your screen and prints still don't match it's time to turn your attention to your printer. To start with, make sure that you're using premium inks. Yes, they're eye-wateringly expensive, but they are also more consistent than low-priced compatible consumer inks, which translates to greater accuracy. Then, make sure you're using the correct paper setting – glossy, matt and so on. Although your printer will have a range of options, a lot of high-end paper manufacturers also produce 'printer profiles' that are tailored to a specific paper. This should be more accurate still, so check their website or drop them an email to see if there's a profile you can use.

The ultimate solution, though, is to have a profile made for your particular printer and paper. Although you can buy the hardware and do this yourself, it can be quite expensive, so an alternative is to use a commercial profiling service that will create your own bespoke printer profile. What this profile will do is tweak the printer's output so that the brightness, contrast and colour are as accurate as they are on screen, although it's worth noting that a profile will only apply to one specific printer, paper and ink combination — change any one of those and you will need a new profile.

## ◎ **What's the difference between ppi and dpi?**

The terms ppi (pixels per inch) and dpi (dots per inch) are commonly used to describe resolution, and are often – and wrongly – used as if they are the same thing. This isn't the case. Specifically, dpi only relates to the resolution of printers, which produce images using dots of ink, whereas ppi relates to digital images, which are constructed from pixels. Admittedly, these two resolution measurements seem very similar (hence the confusion), but it's important to appreciate the difference, particularly when it comes to printing your photographs: a 300ppi digital image can look very different to a 300dpi printed one.

DPI – PRINTED IMAGE

PPI – DIGITAL IMAGE

▲ Every few weeks my calibration program reminds me that I need to check my monitors. As part of the process the software displays 130 or so colours in turn that the colorimeter 'reads'. By knowing what these colours should look like and measuring how they actually appear on screen, the software can create a profile that tweaks my displays so that I'm seeing the 'true' colours.

▲ Under heavy magnification, the difference between pixels and dots is clear.

# Software

You'll need an app to push the pixels in your photos around, but what should you be looking for?

### ◎ What software do I need to edit my photos?

At a basic level, the apps that come as part of Windows and macOS will let you crop, rotate and tweak your images. They're not comprehensive but they might be all you need if you shoot JPEGs and do as much as you can in-camera. At the opposite end of the software spectrum are the pro's favourites – Adobe Photoshop, Adobe Lightroom and Capture One – which bring Raw processing, advanced editing tools and pro-level colour management to the table. Between these extremes lies a host of 'middleweight' editing apps that can provide a comprehensive editing experience without breaking the bank. Adobe Photoshop Elements, Affinity Photo, DxO PhotoLab, Exposure X6 and ON1 Photo RAW are all worth investigating here, with free trials offering you a 'try before you buy' option.

▲ Adobe Photoshop and Lightroom are the 'standard' for photographers, but they're not the only options. I've started using Exposure X6 a lot for my Raw processing.

## ⚙ How can I keep track of all the digital photos on my computer?

This is all about filing your images in a way that you understand, so you can find them at a later date – what works for one person might not work for someone else. Personally, I use a series of themed folders on my computer (Landscapes & Places, Portraits & People and so on), which contain additional sub-folders such as specific locations or the names of portrait subjects, and then additional dated folders within those. This hierarchy provides a fairly painless way of locating the folder of images that I'm looking for, but to find a specific image requires some software-based assistance. In my case, I'll open my image folder in Adobe Bridge, which allows me to preview my images and apply various filters to find a specific shot – for example you can filter by date, by location (if shots have GPS data added to them), by 'keywords' that you can add to help identify your shots and a whole host of other criteria.

Some editing programs (such as Adobe Lightroom) have this type of cataloguing built in, which creates a fully integrated working environment, but if yours doesn't (or, like me, you find yourself using a variety of editing apps), Bridge provides a standalone alternative.

▼ When I'm sorting through a folder of images, I'll use Adobe Bridge to assess my images, giving the ones I'm interested in pursuing further a 'star rating'. I'll also use Bridge to search through my hard drives, using its various filters to narrow down my hunt for an elusive shot.

## ⟳ Should I convert my Raw files to 8-bit or 16-bit? TIFF or JPEG?

If you're shooting Raw, it's generally because you want the highest quality image, so my advice would be to output your carefully processed Raw files as 16-bit TIFFs, ideally in the ProPhoto RGB colour space (see opposite). The reason for this is simple: although you'll be generating large file sizes, you'll be creating the highest-quality image that you can in terms of its colour fidelity and tonal range. You will then be saving it in a 'lossless' file format, which means there is no loss of image data when the image is saved. By comparison, a JPEG file uses 'lossy' compression that creates smaller file sizes, but discards some image data in the process (a lot of the time this won't be noticed, but it is both irreversible and cumulative, so opening and resaving a JPEG image as a JPEG loses a bit more data every time).

Admittedly, for a lot of applications this is overkill, and in a lot of instances you will need to re-save these images to make them usable, but in my opinion it's far better to 'dumb down' an image for use online, than to discover that JPEG artefacts or a reduced resolution are limiting a large-scale print and your only option is to go back to the Raw file and start again.

▲ This shot was always going to need a significant amount of processing work to draw back highlight detail and pull out the shadows. Exporting the Raw file as a 16-bit TIFF in the ProPhoto RGB colour space ensured that I had as much information as possible to work with, minimizing any loss of quality.

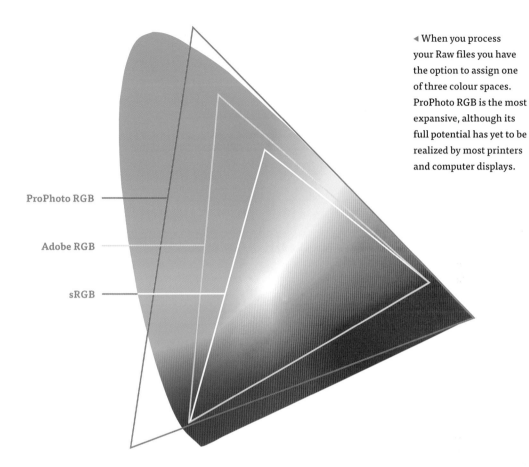

ProPhoto RGB

Adobe RGB

sRGB

◀ When you process
your Raw files you have
the option to assign one
of three colour spaces.
ProPhoto RGB is the most
expansive, although its
full potential has yet to be
realized by most printers
and computer displays.

## ⟳ What's a 'colour space' and why have I got so many to choose from when I convert my Raw files?

As you saw on page 78, a colour space describes a range of colours, and your camera will typically give you two options: sRGB (ideal for websites) and AdobeRGB (great for prints). When you shoot JPEGs, your colour space is assigned to the image when it's saved, but if you shoot Raw, you get to choose a colour space when processing your images, and this gives you a third option: ProPhoto RGB. This has an even wider colour gamut than AdobeRGB, so it allows for an even greater range of colours. In fact, the ProPhoto RGB colour space is so expansive that it exceeds the display capabilities of today's monitors, and printers cannot print its full gamut. So why bother if you can't see or print it? Well, if you like to edit your images and regularly make significant colour shifts, having an ultra-wide gamut means you can make

bigger adjustments without degrading your images. Also, it potentially makes your images more future-proof. As display technologies advance they become ever more capable of showing a wider gamut, so while you may not be able to benefit from your wide-gamut images today, there's nothing to say you won't be able to enjoy them in full in the future, either on screen or in print – like a fine wine they will just get better with time.

# Techniques

From basic image optimization to advanced editing, there's plenty to explore in the digital darkroom.

## ⟳ How can I remove noise from my pictures?

Noise reduction is a staple part of most image-editing programs, and there are also dedicated noise-reduction apps and plugins that will do a great job at removing either, or both, of the two types of noise you can encounter in your digital images: coloured speckles (chroma noise) and a 'grainy' texture (luminosity noise). However, before you explore the software-based options, there are several steps that you can (and should) take to minimize noise when you shoot. First off, try and keep the ISO as low as possible, perhaps by opening up the aperture a little more, rather than dialling in a higher ISO. Second, try and avoid ultra-long exposures – making multiple shorter exposures and blending them is a less 'noisy' alternative, as demonstrated by star trail photographs (see page 131).

It will also help if you shoot Raw, so you're getting the maximum amount of information from your sensor, and that you nail your exposures. Getting your exposure right is really important, because while you can fix the brightness of an underexposed shot in your editing software without any problem, lightening an image exaggerates any noise that's lurking in the dark tones, which are the areas affected most by noise. None of these measures will fully prevent noise, but they will minimize it, so your software doesn't have to work so hard – and that will help ensure you end up with detail-rich images.

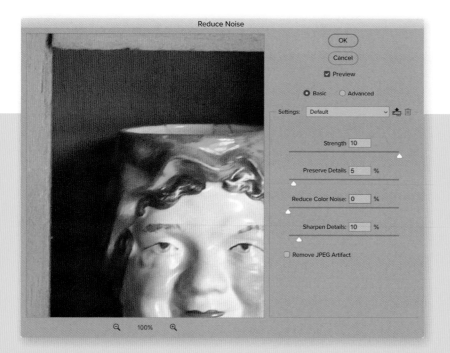

◀ One of the first things to appreciate when reducing noise is that it's a reduction process, rather than a single action that can be completed in one step, and it often involves finding the balance between reduced noise and detail loss or softening. Personally, I'd rather have a sharp, noisy image than one that has been softened through aggressive noise reduction.

# ⟳ My shots look dull and lifeless – how can I perk them up?

There are three adjustments that I'd recommend trying: Levels, Curves and Saturation/Vibrance. Sometimes you might only need to apply one of them, while at other times you may need all three, but they are usually all it takes to make an image 'pop'.

● **Levels:** When you open the Levels dialog you will see a histogram that shows you where the white and black points in your image are. If the histogram is stopping short of one end of the scale, try dragging the corresponding slider inwards so it touches the graph; if both ends are short, drag both sliders. This will make sure the tonal range in your image runs from black to white.

● **Curves:** Open up the Curves dialog and apply a gentle, contrast-boosting 'S' shape by raising the upper right part of the curve and lowering the bottom left part of the curve. The more extreme your 'S' shape is, the more extreme the contrast will be.

● **Saturation/Vibrance:** I'd suggest trying a Vibrance boost first, as it protects already saturated colours from getting blown out, and then a Saturation tweak if your colours still aren't hot enough. Be careful, though, as a little bit of Saturation can make a huge difference, so adjustments generally need to be small.

BEFORE

AFTER

◄ Shot on a grey day in Prague, I made adjustments to the Levels, Curves and Vibrance to liven up this image.

ADJUSTED IMAGE

## ⚙ What's the best way to lighten my images?

If you shoot Raw, then lightening an image when you process it is easy: your Raw-processing software will have an Exposure slider that can fix any slight underexposure, as well as separate controls to lighten (and darken) the highlights and shadows. Although the same (or similar) tools will be available in your editing software if you shoot JPEGs, you won't be able to make such radical adjustments. That's not the only option, though, and if I'm working on a JPEG (or TIFF) file in Adobe Photoshop or Adobe Photoshop Elements, I'd rather use Levels for brightness tweaks than Exposure. Why? Because it lets you tune the black and white points (see below) at the same time as you use the middle grey (gamma) slider to control the overall brightness.

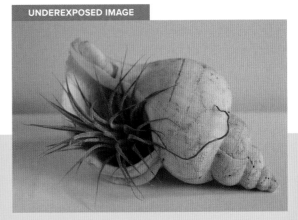

UNDEREXPOSED IMAGE

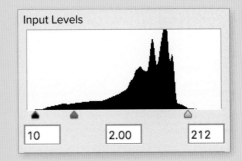

Input Levels

| 10 | 2.00 | 212 |

▲ ▶ This is the underexposed shot from page 53, which needed lightening up. To fix it, I dragged the right (white) slider under the Levels histogram to the end of the graph to set the highlights to white, then shifted the middle (grey) slider left to lighten the overall exposure.

## Is there a way of getting rid of the purple fringes in my shots?

Most image-processing software will have a chromatic aberration removal option. This might take the form of a camera/lens profile that will automatically eradicate fringing based on the pre-programmed characteristics of the lens, or it could be a manual option that lets you 'dial out' fringes of different colours. Often you'll have both options so you can fine-tune the automated result if you need to, or tackle lenses that haven't been profiled – this is especially useful if you're using an adaptor to mount lenses of one make onto a camera of a different make, or are using old manual-focus lenses. In Adobe Photoshop you'll find these options within the Camera Raw plugin and as part of the Lens Correction filter.

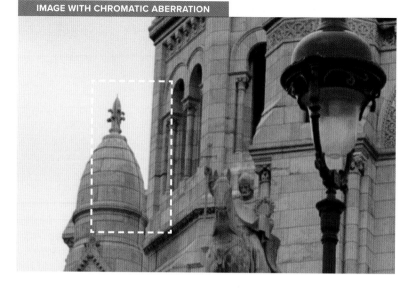

IMAGE WITH CHROMATIC ABERRATION

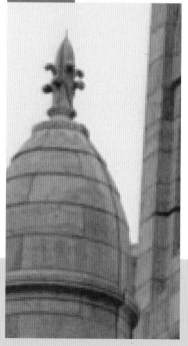

BEFORE

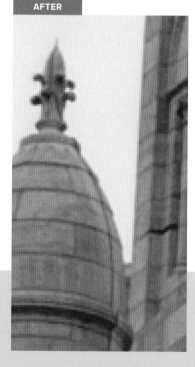

AFTER

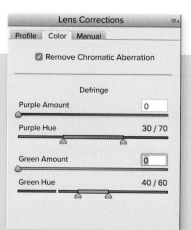

◀▲ Most editing programs have a chromatic aberration (fringe) removal tool. To get rid of the red/green fringes in this shot (from page 30) I simply had to click the Remove Chromatic Aberration button in Adobe Camera Raw and the default settings eliminated the coloured edges.

## In Photoshop, which is better at removing dust, the Clone Stamp tool or the Healing Brush tool?

If you've got any marks that are against a relatively flat tone or colour, such as a dust spot in the sky, the Healing Brush tool is a one-click solution: click on the dust and watch as your software intelligently removes the blemish and seamlessly blends the correction in with its surroundings. It can also do a really good job when you've got dust in more complex parts of an image, so I always tend to give it a go first – you can easily undo any corrections if you need to. However, the Healing Brush tool can struggle if you're working close to the edge of the frame, where there aren't so many surrounding pixels for it to assess, and with fine, complex patterns such as hair and fur. When this happens the Clone Stamp tool is a better option, because you can manually choose the area you want to copy and then carefully select where you want to place it. For really tricky fixes, don't be afraid

▲ For removing dust from relatively flat areas, such as the sky and skin tones, I'd always go with Photoshop's Spot Healing Brush tool – often it's a simple one-click correction process.

to change the size and hardness of the clone 'brush', or the opacity of the tool – sometimes, making multiple retouching passes at a lower opacity builds up a better end result than a single pass. Cloning on a separate layer that you can go back and edit and adjust can be useful, too.

## How do I remove barrel distortion?

Just like chromatic aberration removal – and often found alongside it – most editing programs enable you to remove barrel (and pincushion) distortion, either using camera/lens profiles or manual controls.

▲ Photoshop's Lens Correction filter quickly dealt with the barrel distortion in this shot – see page 34 for the uncorrected version.

## ◎ Is there an easy way to blend different exposures?

The easiest solution is to use your editing program's HDR tool or a dedicated HDR program, either of which will have one-click blending presets, as well as manual adjustment tools. However, HDR isn't for everyone, and the results can start to look quite 'cartoony', with oversaturated colours and crazy contrast. That's why I would rather use layers and masks for my blending work. It's not the quickest or easiest method, but it can give you a more natural-looking result.

▲ ▶ There simply isn't space to cover Photoshop's layer masks in detail, but they're essentially all about revealing and concealing ('masking') parts of an individual exposure. For this example, based on the bracketed images on page 59, I used a couple of simple gradients to blend the sky from the darkest exposure with the foreground from the middle exposure and the bright haze from the lightest exposure. A couple of additional adjustments (Levels and Curves) were used to darken the left side of the image and add an overall contrast boost, respectively.

BEFORE

## ◐ What's the best way to convert a colour shot to black and white?

Although you can simply desaturate an image to get rid of its colour, that's never going to give you the best result. What you need instead is a black and white conversion option that has colour filters. It might sound strange using colour filters for black and white photographs, but they will let you adjust the tones in your image during the conversion process. The simple rule is that a filter will lighten its own colour when you transform it from colour to black and white, and darken colours opposite it on the colour wheel (see page 92), so a red filter will make reds appear as a lighter shade of grey, while greens will appear darker, allowing you to control how those colours translate into monochrome.

These tools are found in most editing programs, but if you get seriously into black and white photography, you may want to explore a dedicated black and white app such as Silver Efex Pro – many of these apps offer tools that emulate the traditional darkroom, as well as film simulation profiles (see page 162).

▼ ▶ Exposure X6 lets me adjust the individual tones when I convert a shot to black and white through using sliders in the Color palette. Similar controls are found in the Black & White adjustment panel in Photoshop and Lightroom, and in each case you have full control over the conversion. In this instance I lifted the Cyans to lighten the tones of the tiled roof.

**Color**

Color Filter
Preset: *Off
Density 0
Color
Cool/Warm 0
✔ Preserve Brightness

Color Sensitivity
Preset: Default*
Reds 0
Oranges 0
Yellows 39
Greens -10
Cyans 77
Blues -40
Purples 0
Magentas 10

## ◌ Can I make my digital black and white photos look like they were shot on film?

Yes. The simplest way of adding a 'filmic' look to your digital images is to use a program or plugin that has this type of film emulation built in, such as Silver Efex Pro, DxO FilmPack or Exposure X6. With a click of the mouse, these programs will tweak the contrast of your shot to match any one of an array of real-world film stocks, and add a grain texture based on the actual film itself. You could also add a scattering of faux dust and scratches, or a film-style border complete with frame numbers, although for most people this is a step too far. Of course, if you want a truly authentic film look, you could just shoot on film to start with...

BEFORE

▲▶ Shot decades ago on slide film, this raw scan was given a new lease of life by Exposure X6's 'wet plate' and 'Daguerrotype' presets. More conventional film-simulation options are also available!

COLOUR ORIGINAL

MONO CONVERSION

PAINTED IMAGE

## What's the easiest way to give my colour shots a vintage look?

Thanks primarily to Instagram there's a whole host of filters that will give your colour photographs a supposedly 'vintage' look. But while I'm a fan of these desaturated, colour-shifted filters, I wouldn't call them authentic — most of them are more interested in creating pseudo-nostalgic warm and fuzzy feelings than accurately emulating real-world vintage colour photographs. So, for a more authentically retro aesthetic, why not try hand-colouring a black and white shot

instead? Sure, it's not as easy as a one-click filter, but the result will be far more personal and its origins can be traced right back to the early days of photography — and what could be more vintage than that?

Start by converting a colour shot to black and white in your editing software, and then reduce the contrast slightly (early black and white film tended not to deliver deep blacks).

◀ I chose not to colour the whole of this image, but to create a 'colour spotlight' that naturally draws attention to the three main birds at the centre, with a hint of colour in the wooden boxes they're perched on to indicate the material the boxes are made of.

You can now use your software's painting tools to add colour. You'll find this is easier to do if you work on a separate layer, rather than the image itself, perhaps even using a layer for each colour that you apply so you can go back and refine them independently. Use the opacity settings for both the layer(s) and painting tool to control the density of the colour, applying flat 'washes' of colour to create a deliberate 'painted' look.

For inspiration, check out the work of Czech photographer Jan Saudek (although be aware that much of his erotically charged work is NSFW).

## ⟳ My editing program has a 'split toning' option – what's that for?

Split toning originated back in the black and white darkroom, when printers would use two different toning baths to add two separate colours to their black and white prints, usually using one to tone the shadows and another to tone the highlights. A traditional combination is blue toner to cool darker tones, and sepia toner to warm the highlights (introducing a complementary cool/warm colour scheme). As digital editing software isn't constrained by real-world toner chemicals, there is now even more creative choice.

◀▲ I used Exposure X6 to split tone this floral close-up, using a classic complementary colour combination of blue for the darker tones and a warm orange/brown for the lighter areas.

## ◐ Can I only split tone black and white photos?

Although split toning was only ever applied to black and white prints made in a darkroom, it's now widely used in colour photography as well, although it's often referred to as 'colour grading', after the technique employed in TV and movies. It is quite common for film-makers to 'grade' their images, with shadow areas often given a blue or green tinge, and highlights taken towards orange (those complementary colours again). Sometimes the toning is so subtle that it's almost subliminal, while at other times it can be fairly obvious, or even exaggerated. In each case, the reason for this particular colour combination is that it makes skin tones stand out from their surroundings, which means the viewer's attention is drawn to the actors in the frame. It's that exact same attention-grabbing use of colour that you can use in your still photographs to add some cinematic drama.

▲ Most editing programs will let you adjust the colour of the highlights and shadows independently. Making the shadows blue/green and the highlights a warmer orange adds a classic cinematic tone.

## ⟳ Strange lines have appeared on some of my digital photographs – what's happened?

There's always a risk with digital images that the data creating them can become corrupted, which basically means the underlying file has been damaged in some way. Gremlins can creep in while images are being copied or saved, or if your computer crashes, but often you'll never really know the cause – I've discovered images in my archive that were fine when I put them there, but have seemingly 'fallen apart' over time, despite being untouched. In some instances, your software just won't recognize a corrupt image any more, while at other times it will still open the file, but the damaged data will result in the image breaking up somehow. Unfortunately, you cannot prevent a file from becoming corrupted, which is why making regular backups of your digital photographs is a good idea – if you have more than one copy, that should at least mean you have one version in tip-top condition.

▲ Corrupt files can manifest in numerous ways. This first image appeared on my hard drive with a strong cyan bar across it, while the second shot gained the graphic black and white shape at the left. I quite like the second shot, though, so I decided to make a feature of the entirely random defect!

## ⚙ Someone told me that digital photographs need sharpening – when and why should I sharpen my shots?

There are two points in the life of an image where sharpening can be beneficial. The first – known as 'capture sharpening' – happens as soon as the image is generated in-camera. If your camera has got an anti-aliasing filter, this will soften your images very slightly as it combats moiré, so sharpening your photographs counters this (images from cameras without anti-aliasing filters can also benefit). If you're shooting JPEGs, this sharpening can be applied using in-camera sharpening settings, but keep this set to the minimum amount so you don't overdo it. With Raw images you can apply a small amount of sharpening when you initially process the shot, but zoom in to a 100 percent preview and let your eyes guide you – if your shot looks sharp enough already, it probably is.

The second sharpening stage – known as 'output sharpening' – happens after you've done all your editing work and are ready to print your image or show it on screen. You should resize your masterpiece to the relevant output dimensions before sharpening it, as the amount of sharpening needed will depend on the output size. Usually, this means less sharpening for a small image that's going to be viewed on screen, and a greater amount of sharpening for a print (larger prints often require more sharpening than smaller ones, and those that are going to be printed on matte papers may need more than those destined for a glossy output).

It's worth stressing that the sharpening you apply here is specific to the chosen output, so it's a good idea to save an unsharpened 'master' image that you can use to create resized and sharpened versions.

◄ Seen under the Loupe (magnifier) tool in Adobe Bridge, this Raw image is sharp, but not as sharp as it could be, due to the camera's anti-aliasing filter and a lack of in-camera sharpening.

# How should I sharpen my photos?

As mentioned, capture sharpening should happen when you process your Raw files (if necessary) or by applying the minimum amount of in-camera sharpening to JPEGs, while output sharpening is the final step in the process, and the one we'll look at here. Because the amount of sharpening required depends on the size and content of the shot, you need to take control of the process, so a one-click sharpening adjustment just won't cut it – you need a tool with options.

Working in Adobe Photoshop, I use the Smart Sharpen filter, which is a variation of Unsharp Mask (an older sharpening tool). Smart Sharpen works by increasing the contrast along the edges in an image, which gives the impression of improved sharpness, and it does this via a pair of controls: Amount and Radius. Amount controls the strength of the sharpening, while Radius determines how many pixels around what is seen as an edge are sharpened – the higher the radius, the greater the 'band' of sharpening around an edge.

As every image is different, there's no 'ideal' setting, so it's a case of viewing the image at 100 percent (so you can see the sharpening effect) and adjusting the sliders to suit. Set the Remove option to Lens Blur, as this will help the filter actively identify and target edges within an image (the 'Smart' in the filter's name), while leaving flat areas alone. Additional tools enable you to apply noise reduction and adjust the amount of sharpening applied to shadows and highlights for even greater control.

▶ Using a small amount of sharpening when the Raw file is processed will quickly remedy the softening effect of a camera's anti-aliasing filter.

▶ Photoshop's Smart Sharpen filter will prepare an image for output.

CAMERA SHAKE DETAIL

## ◎ Can I fix camera shake?

As well as optimizing an image, sharpening can also help reduce the appearance of blur caused by camera shake. However, while it can make minor softening appear acceptable – especially if you don't enlarge the image too much – the best way to 'fix' camera shake is to avoid it to start with by using an appropriate shutter speed (see page 67), image stabilization (if possible) or a tripod.

▲ Shot on a very windy day from an exposed position, using a 200mm focal length, this shot was marred by camera shake. Despite trying my best to alleviate it, the image still isn't as sharp as it could (and should) be when viewed up close.

## How can I prevent people from stealing the images I post online?

Honestly? You can't. As soon as an image is posted online it can be downloaded by someone else. However, there are a couple of steps you can think about taking to dissuade people from using your images without permission.

The first is to add a watermark to your online images. This could be something as simple as your name or signature in the bottom corner, or a large semi-transparent copyright sign across the centre of your shots. Some photographers swear by this approach, but my feeling is that anything obscuring your image will detract from the photo, which kind of defeats the point of sharing it. At the same time, anything discreet or at the edge of the frame can be cropped or cloned out by a determined picture thief.

Arguably, a better option is to make your images 'size limited'. This means never posting high-resolution images online. Instead, resize any image you want to share so it's maybe 900–1200 pixels along its longest edge. This is plenty big enough for someone to view at a decent size on screen, but not so big that they could turn it into a print – at least not a particularly large or high-quality one (and, let's face it, it's people stealing images for commercial gain that we're most worried about here, not people reposting them on Pinterest). Ultimately, though, whatever you try and do, you have to accept that when you post an image online it can be copied, saved and repurposed. That's the nature of digital files.

▲ Although you can slap a big copyright notice across the centre of your images (and some people do), it only detracts from the photograph.

◀ A smaller, more discreet label is an alternative option, but the less obtrusive it is, the easier it will be for a determined picture thief to clone or crop out.

# Index

# Acknowledgements

I can't end this book without thanking my long-suffering partner and kids for putting up with the lost hours as deadlines approached and I needed to disappear to take 'just one more shot' or write 'just one more answer' – Nati, you make this all possible (kids, you're a welcome distraction). Thanks also to Richard at Ilex for the invitation to put virtual pen to virtual paper in the first place. And thanks to you, too, for reading this far – if you've got any other questions you can find me online. I might even know the answer.

# Picture Credits